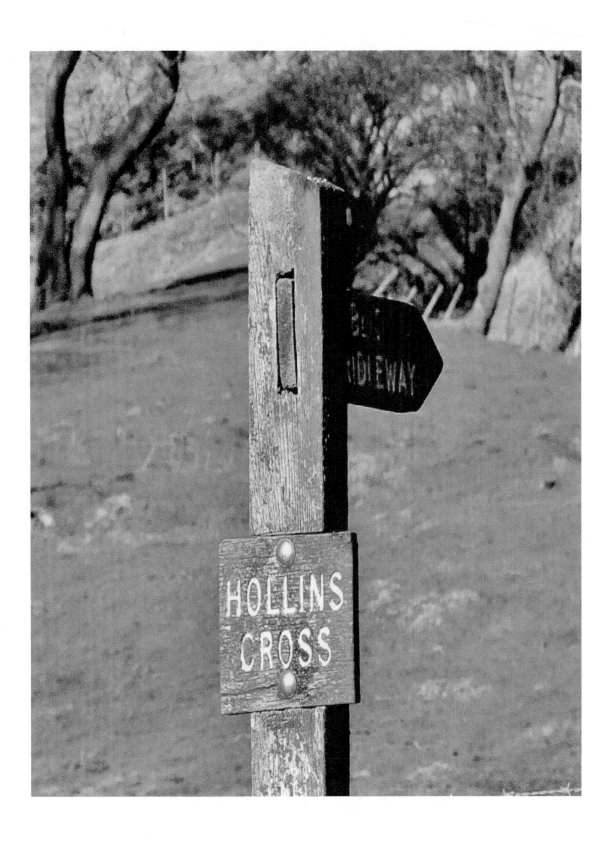

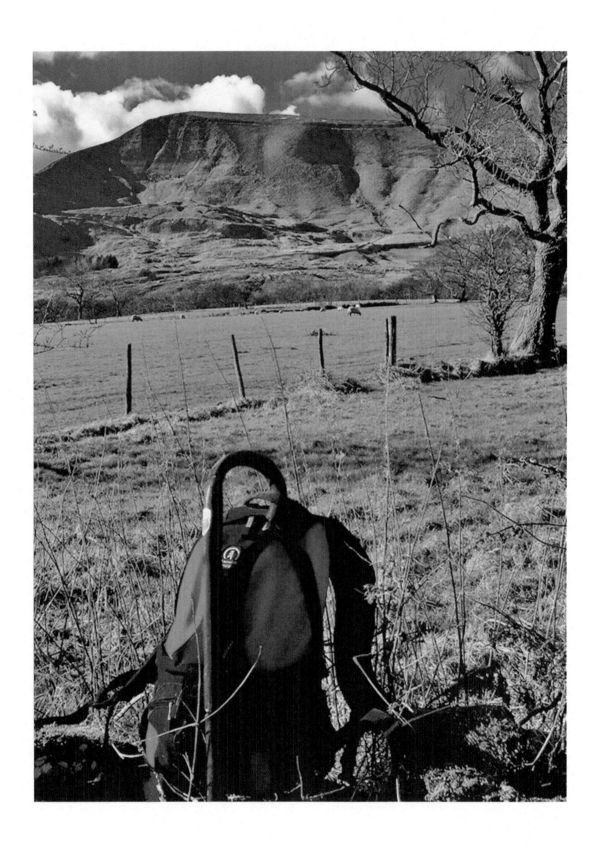

Depicting
The
Peak District

David Norris-Kay

ISBN: 9798849548685

Photographs – David Norris-kay ©2022

Front Cover – David Norris-Kay ©2022

Additional front cover artwork - Meek ©2022

First edition published by
Inherit The Earth Publications
©2022
In conjunction with Amazon.

Editor – CT Meek

Foreword

I first fell in love with The Peak District in 1964 when I was aged fourteen. It was only a short bus ride from Sheffield where I was born, and, armed with my Father's Kodak Brownie camera, loaded with 8 exposure black and white film, I ventured into this wondrous land on solitary walks. The name 'Peak District' reputedly derives, not from mountain peaks, of which there are few, but from an Anglo-Saxon tribe called the Peacs, or Pecsaetan (Peaklanders) who inhabited the area.

The National Park features a few hills of around 1500ft: High moors and gritstone edges, which are popular with rock climbers.

My favourite walk started in the village of Eyam, famous for its association with the Bubonic Plague, which was transferred from London in a bundle of cloth sent to a local tailor. The villagers isolated themselves to prevent the plague spreading to neighbouring areas. A lot of them died. Food was left at a well a couple of miles outside the village and was collected by the vicar, the reverend Mompesson. This is still known as Mompesson's well.

I walked from the village on a long road via Sir William Hill and from there across Eyam Moor to Sherriff Wood and Leam Farm, where I fantasised about living and working. Then I took the road to Hathersage which curved West to face the setting sun. I nicknamed this "The Enchanted Bend". I always arrived in Hathersage when night was falling and caught my bus home from there.

Edale was the most spectacular place on my youthful travels, especially the start/finish of the Pennine way which led through a deep wild gorge called Grindsbrook clough and then onto the desolate high plateau of Kinder Scout where the highest point of The Peak District is situated, at 2008ft. I likened Kinder to Mordor in J.R.R. Tolkien's Middle Earth, from his wonderful book 'The Lord Of The Rings'.

As the years progressed, I discovered Bleaklow, another wild, featureless plateau North of Kinder. After that, The English Lake District and the Isles of Scotland, Skye in particular, but it is The Peak District that is my first love and the place I've always felt at home.

This book includes some of my latest photographs taken in the Peak District. Now I'm in my seventies, I can't get up on the tops any more, but there are plenty of vantage points still accessible to me. I hope you enjoy viewing these photos, and will be inspired to visit the Peak District too.

All the photos were taken with digital cameras by Olympus, Leica, Nikon and Canon, and a selection of lenses.

David Norris-Kay, 2022.

Depicting The Peak District

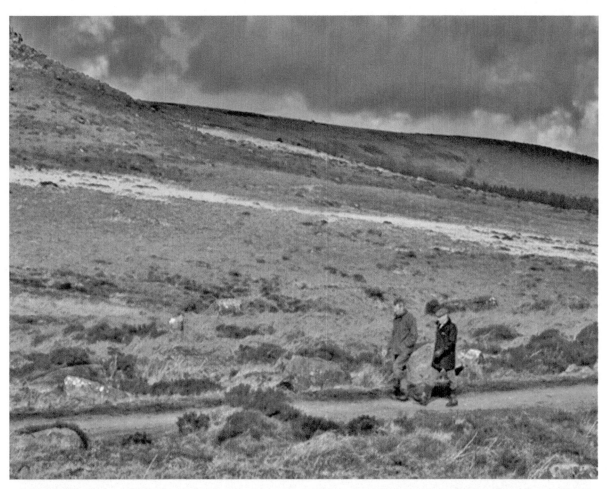

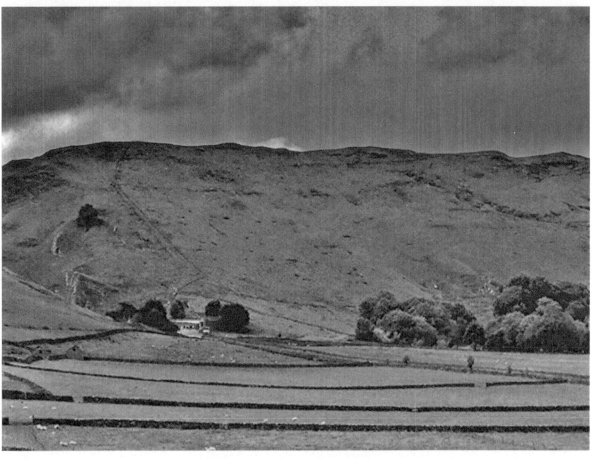

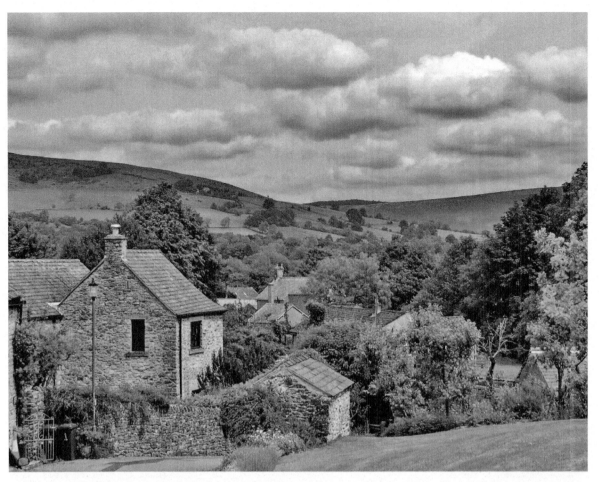

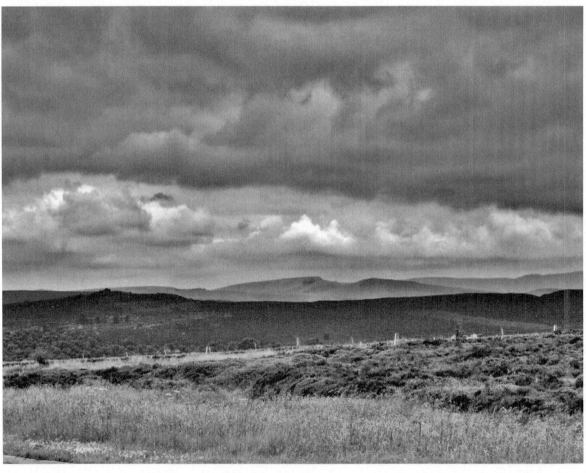

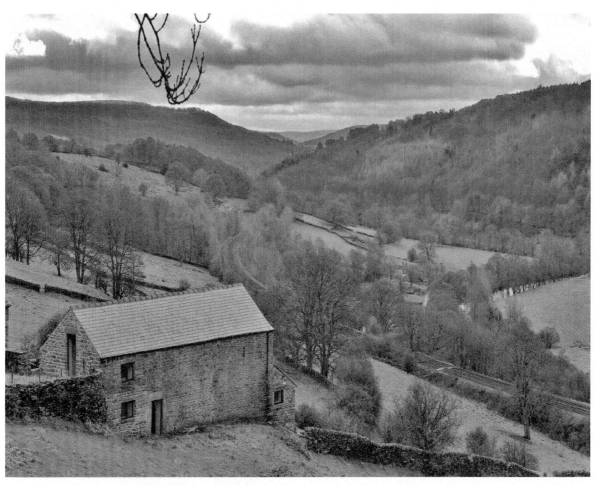

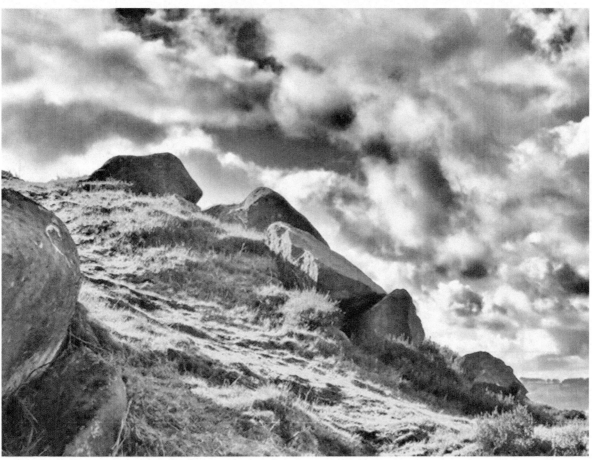

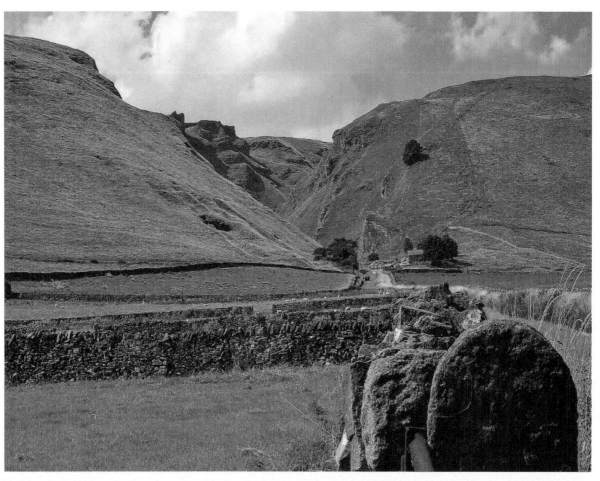

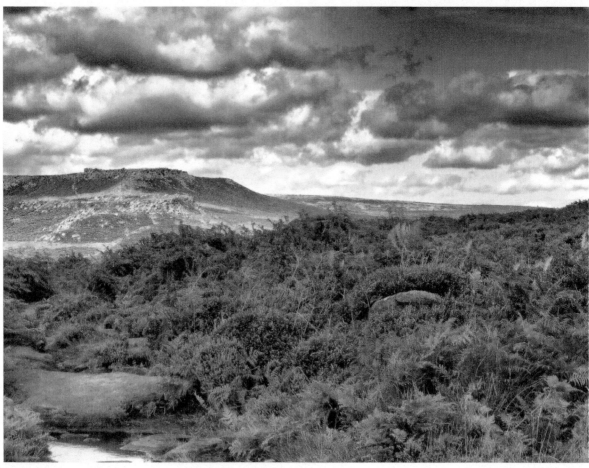

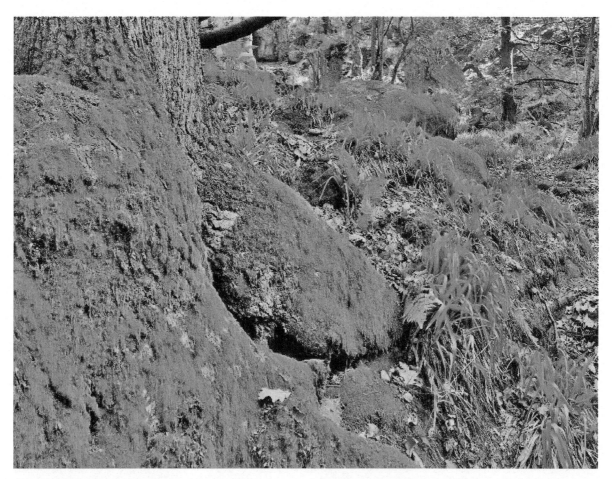

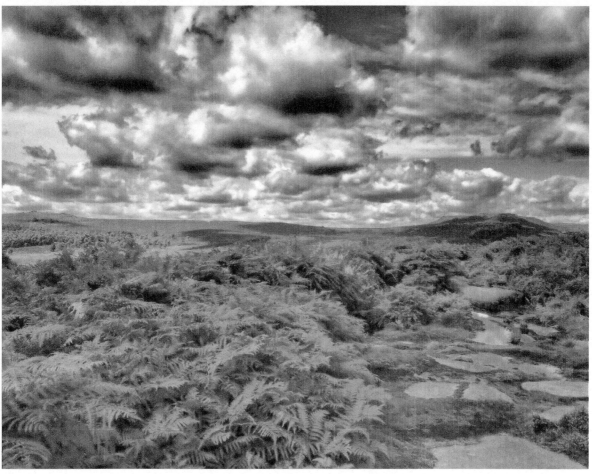

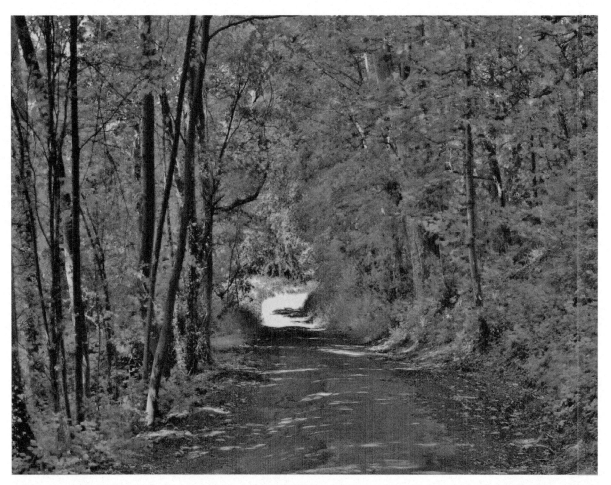

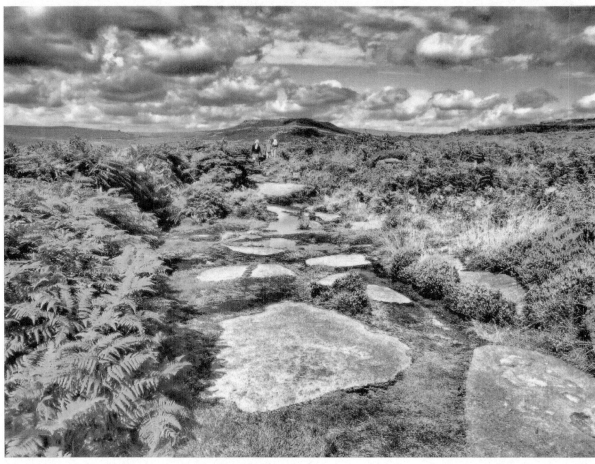

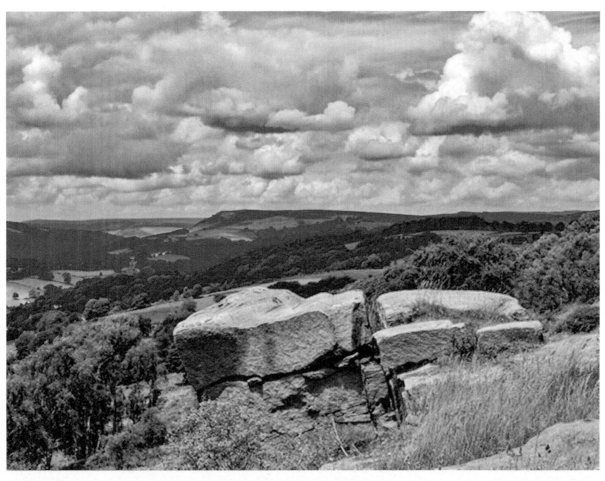

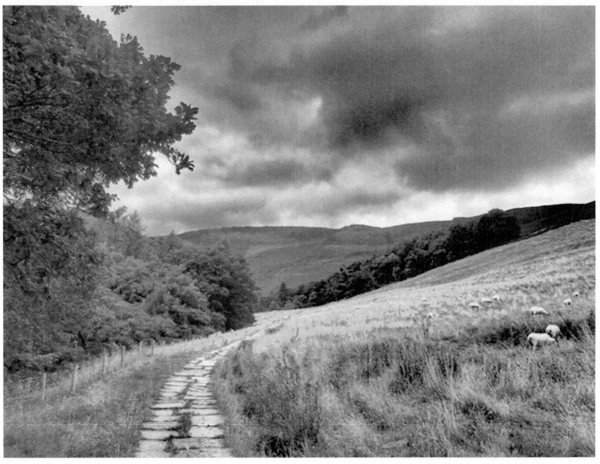

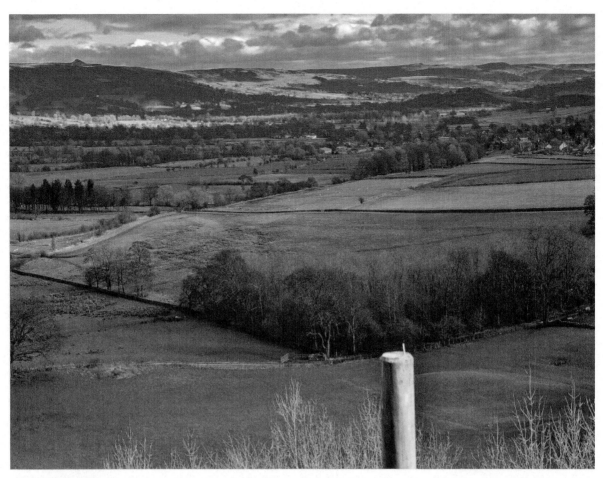

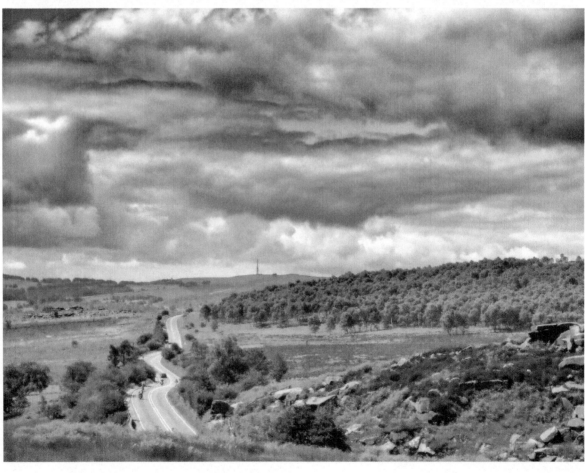

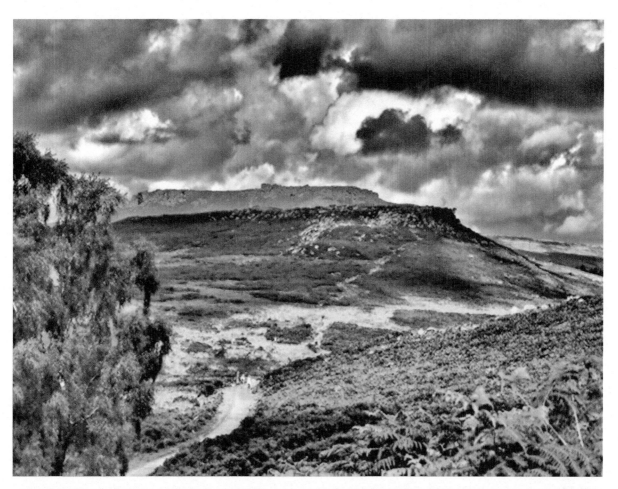

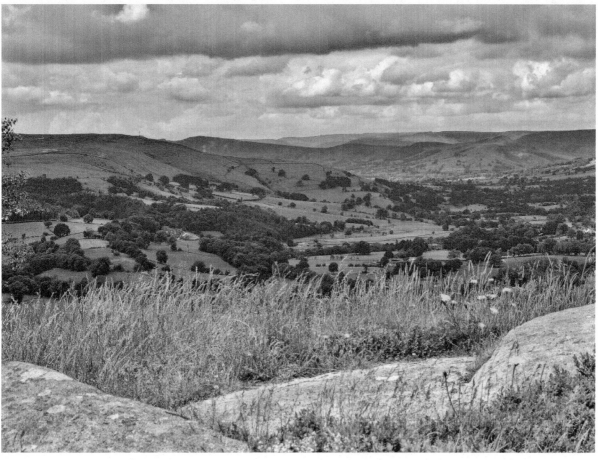

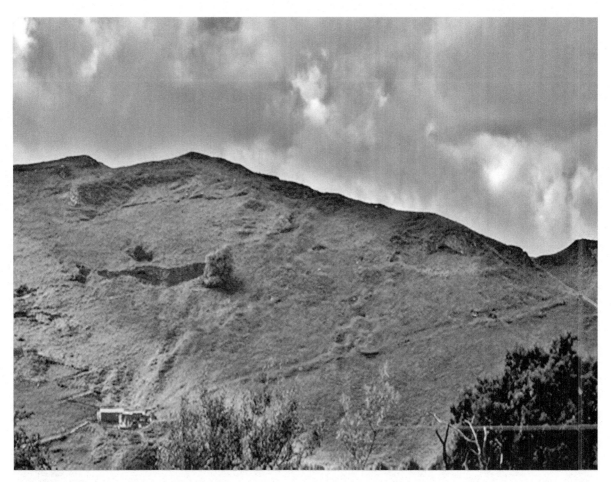

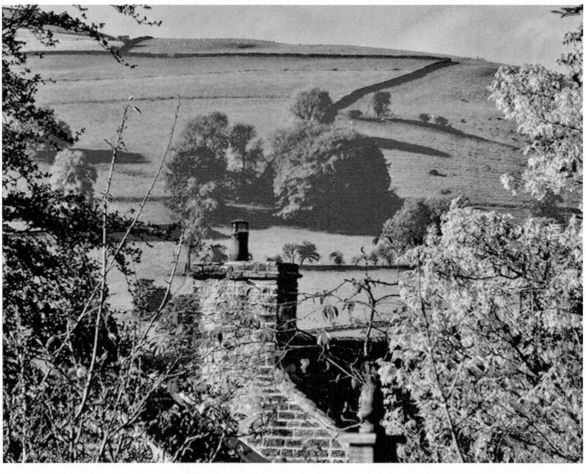

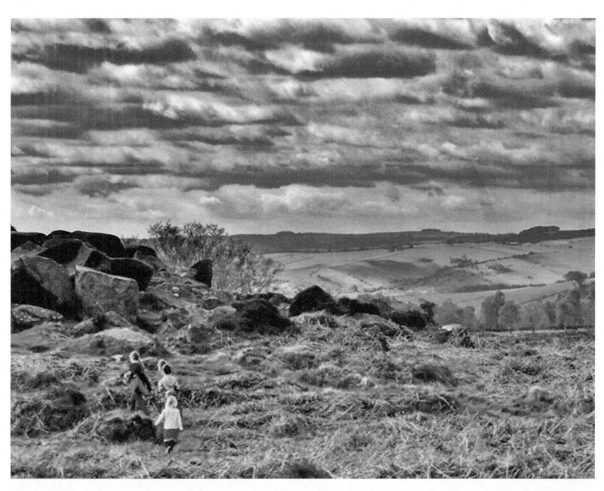

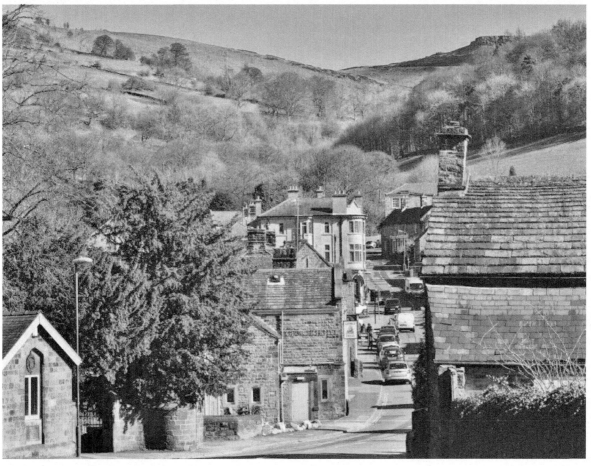

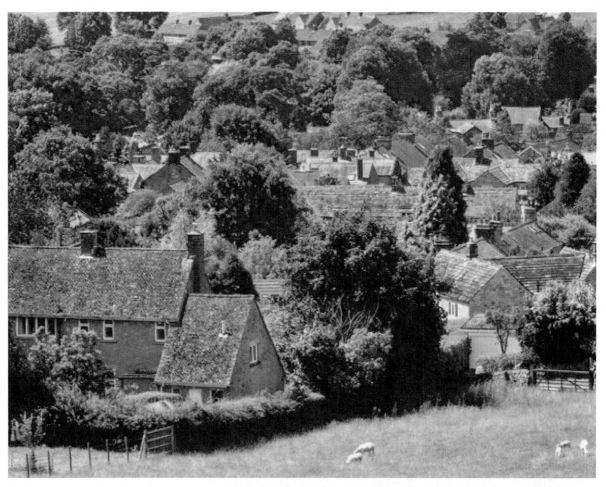

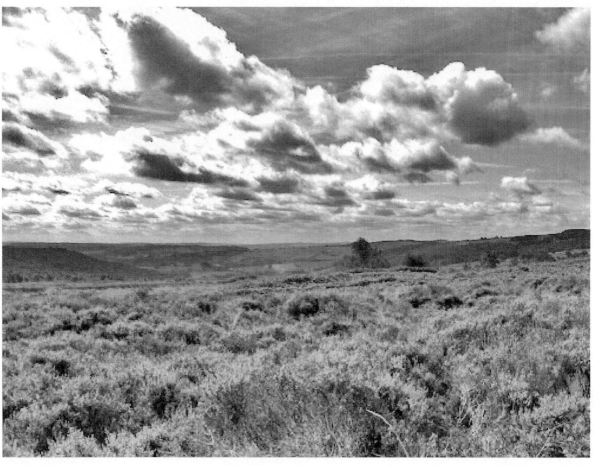

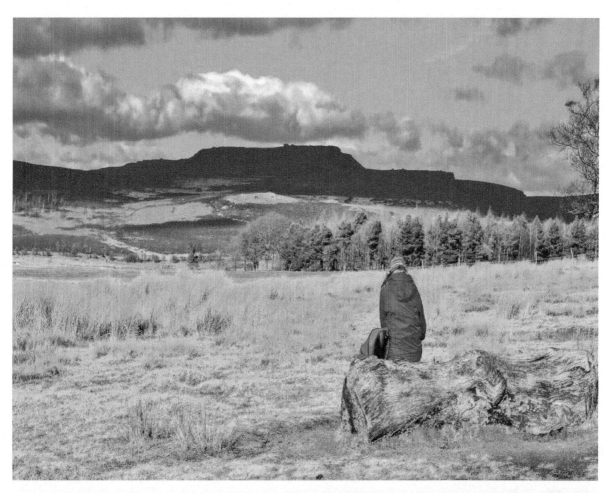

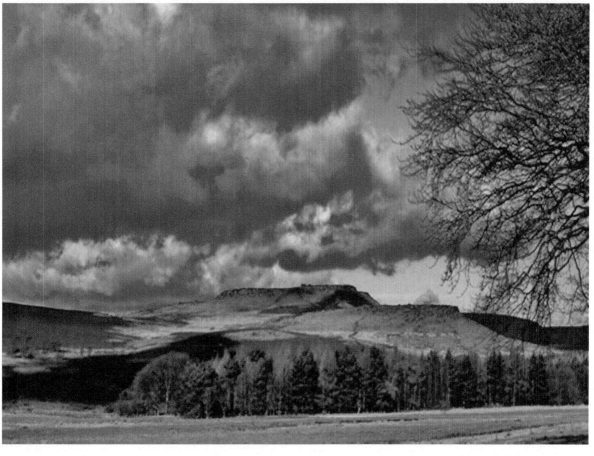

[16]

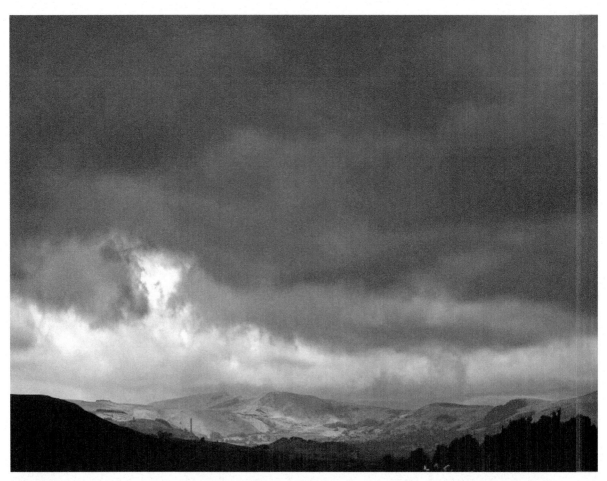

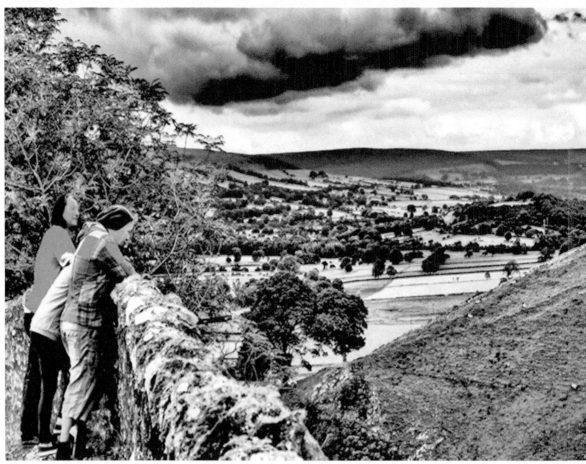

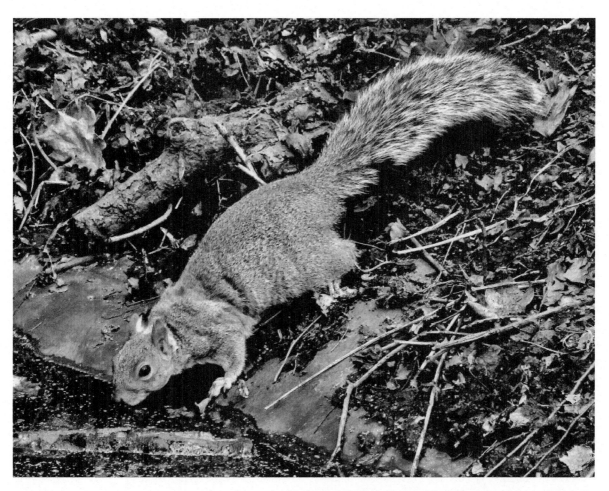

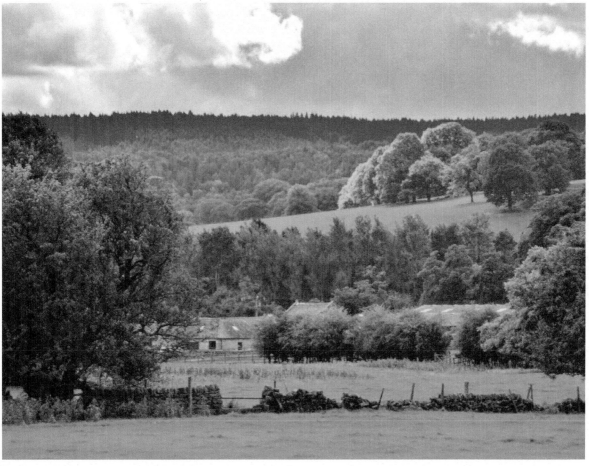

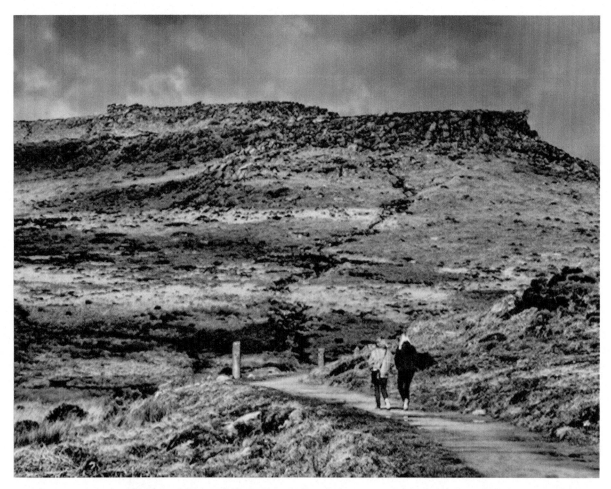

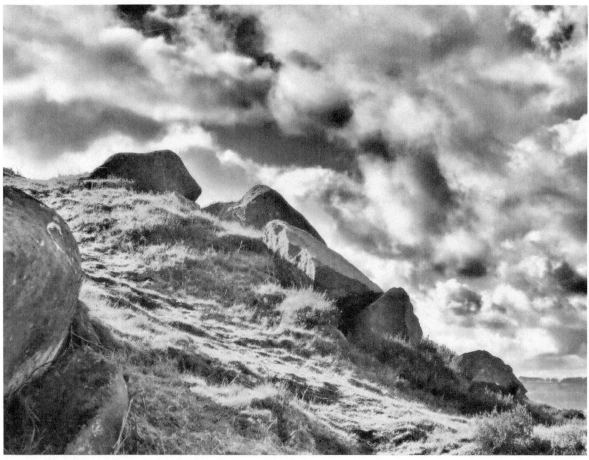

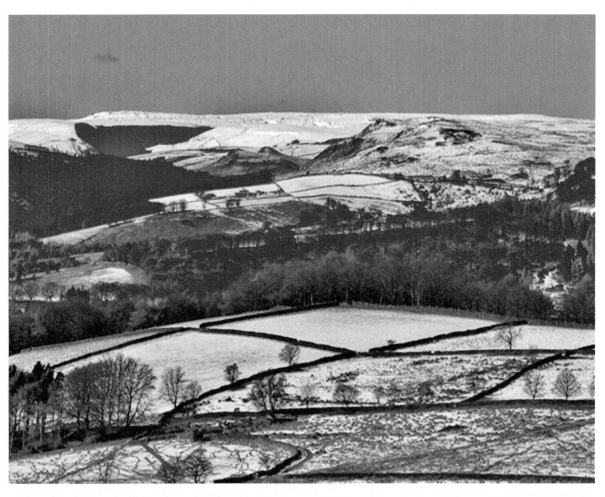

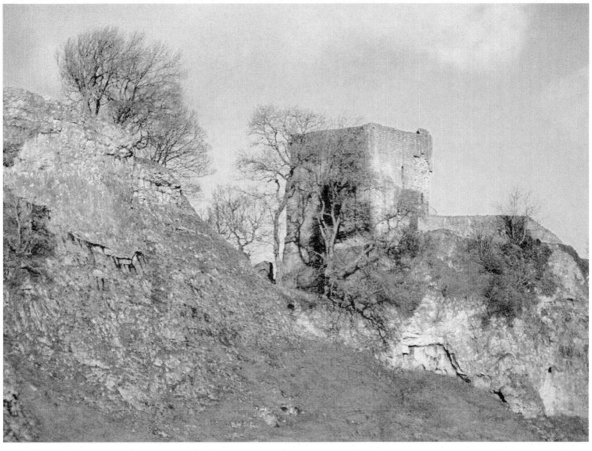

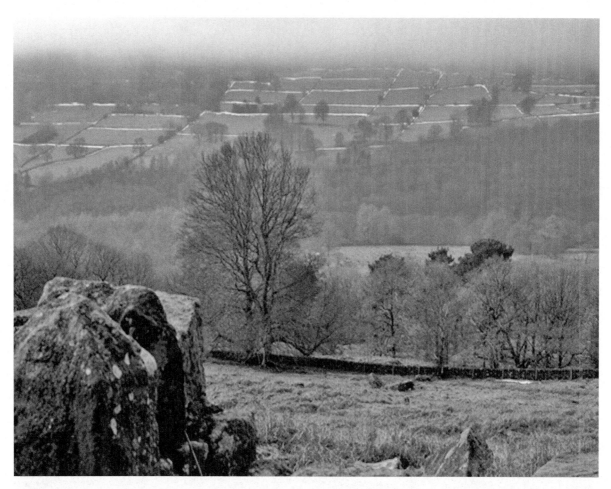

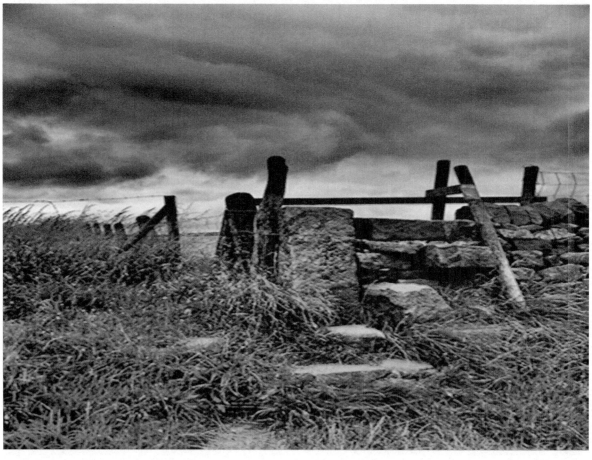

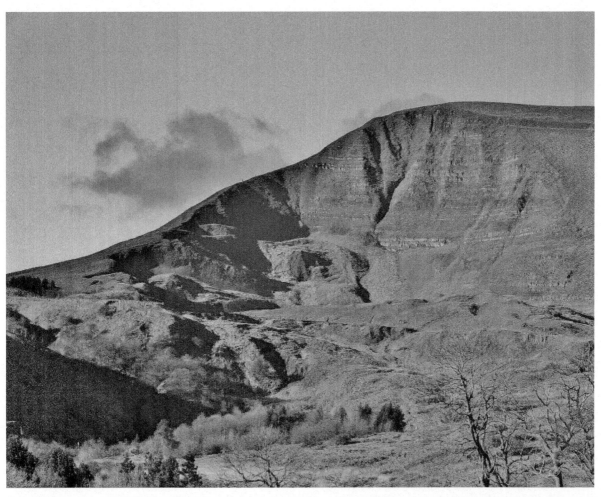

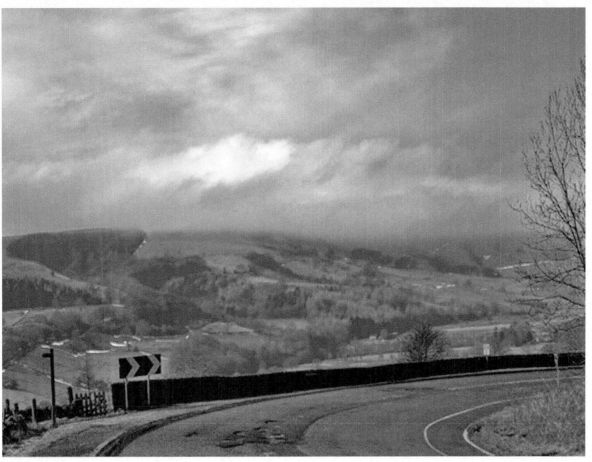

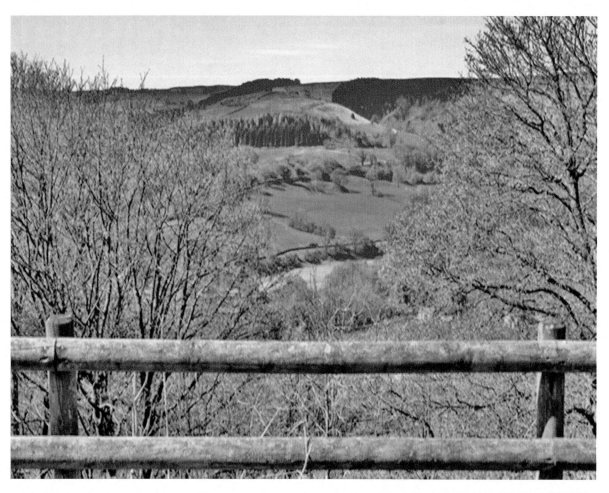

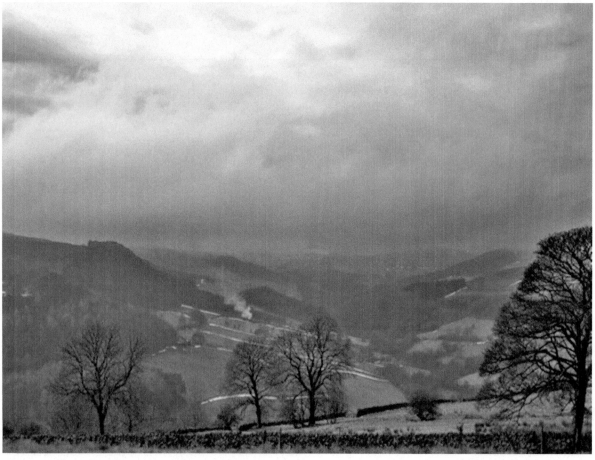

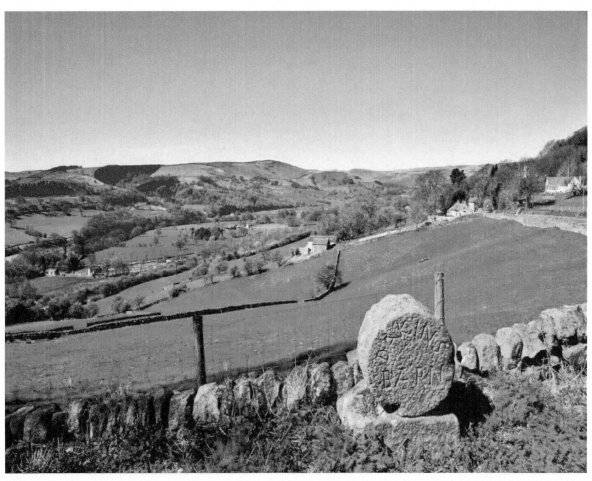

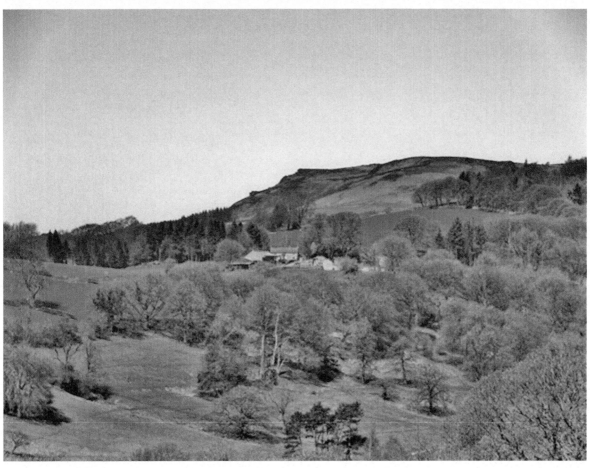

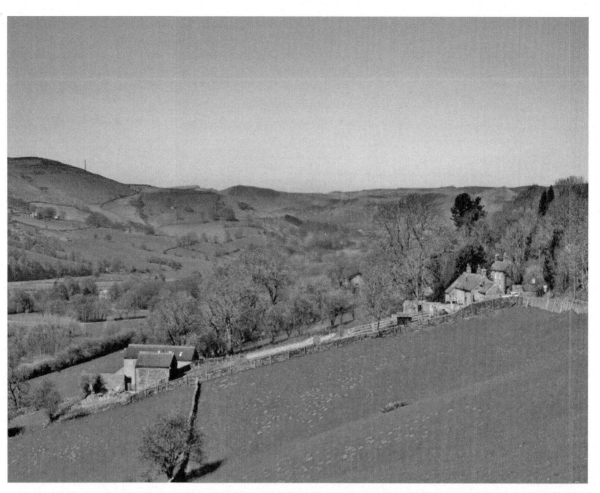

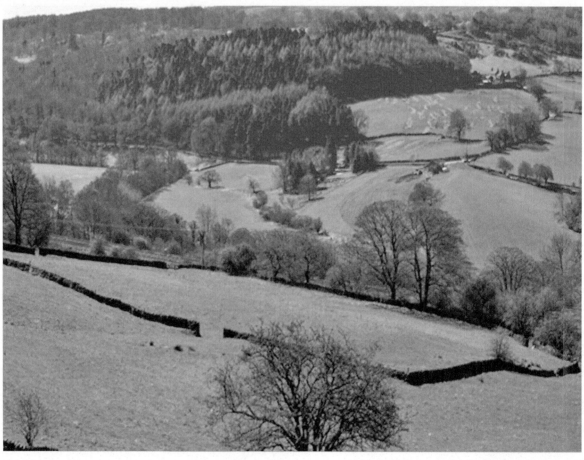

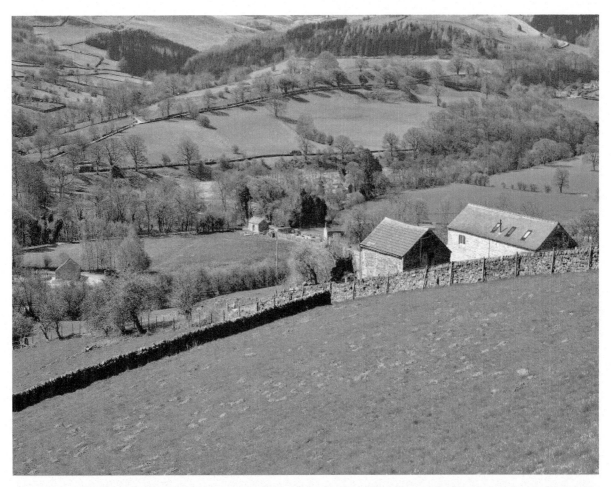

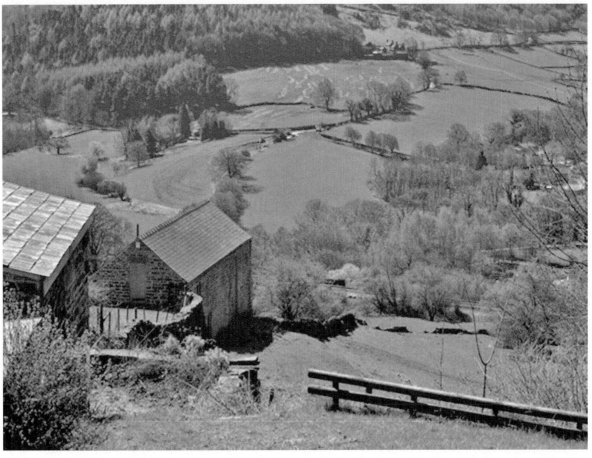

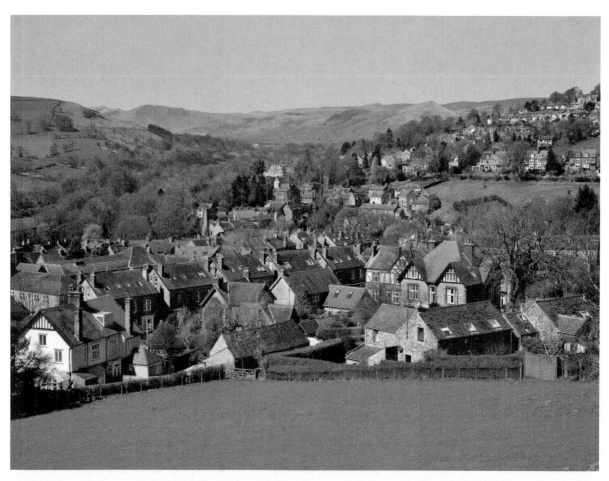

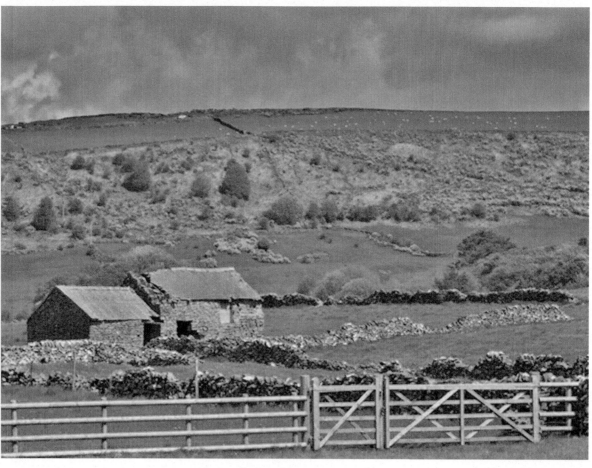

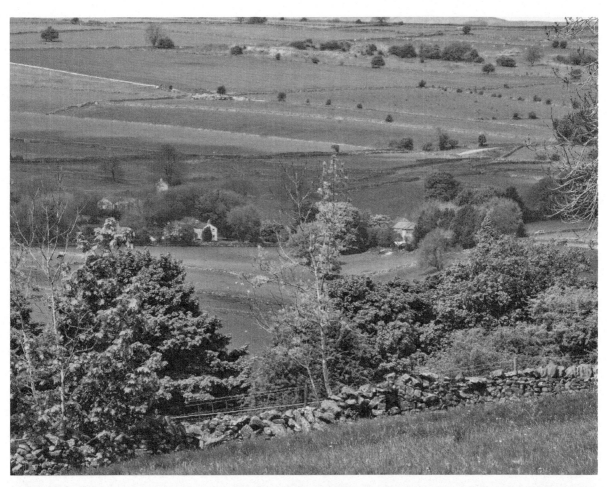

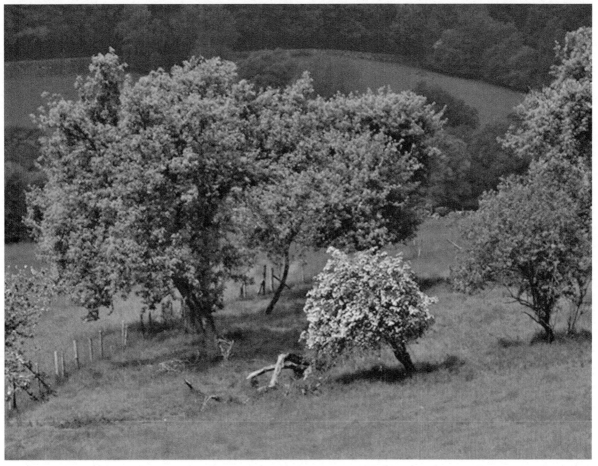

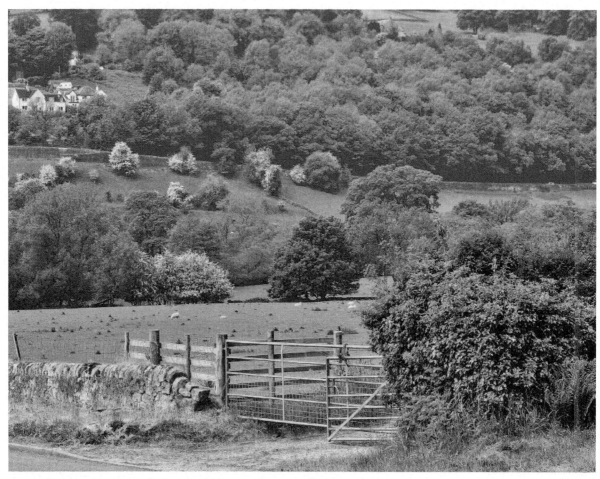

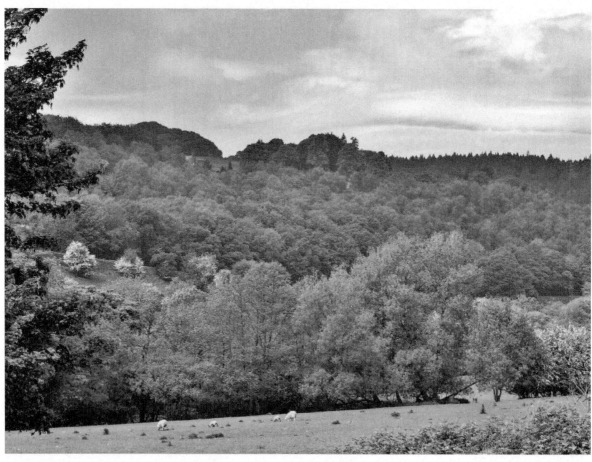

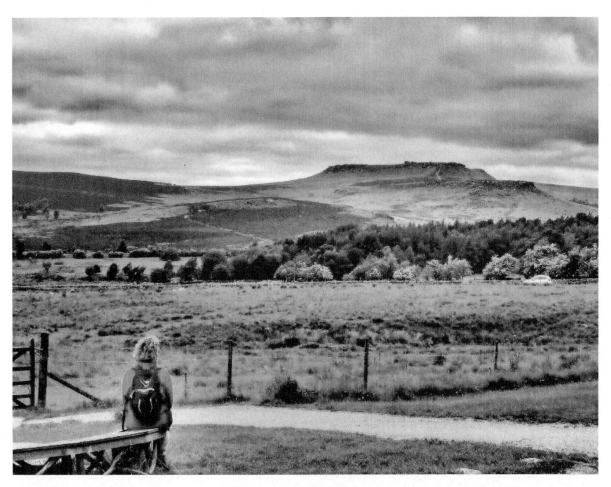

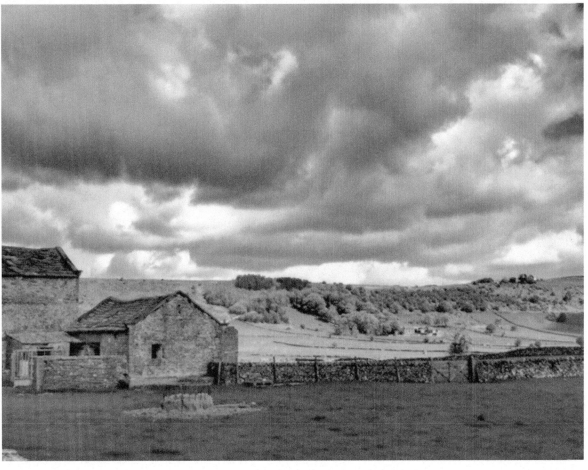

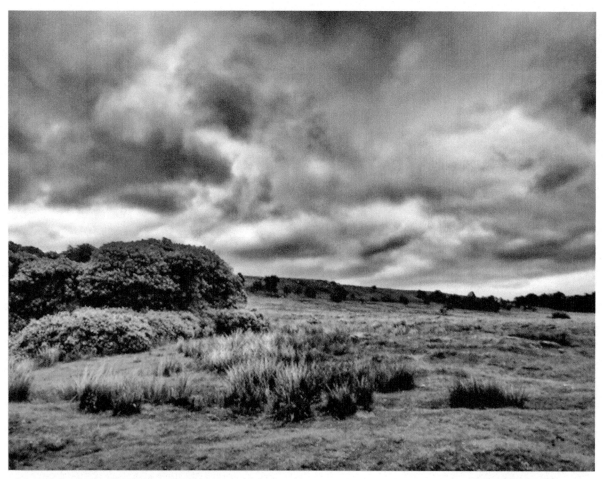

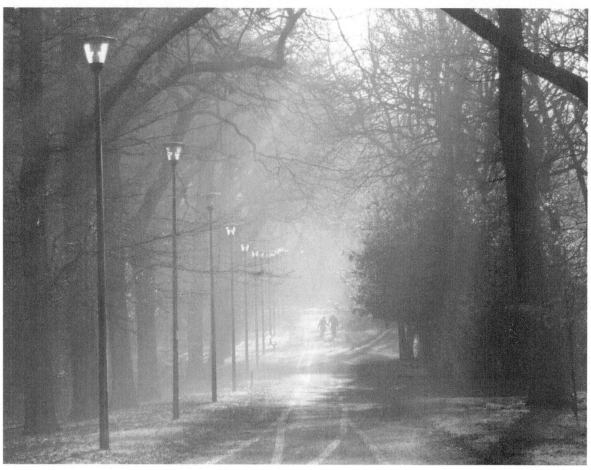

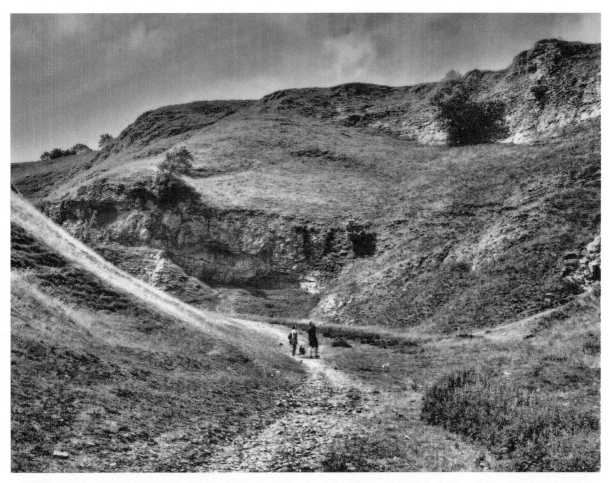

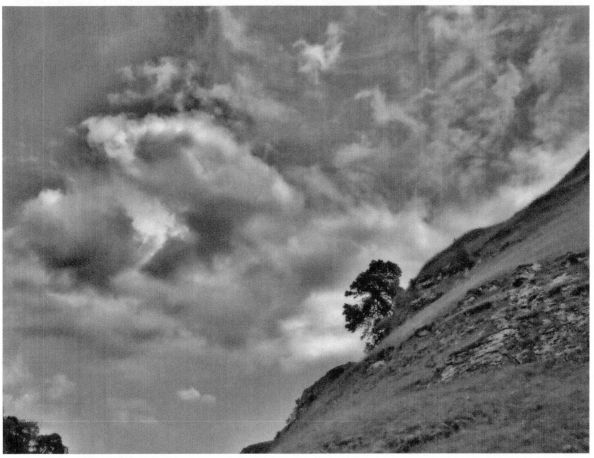

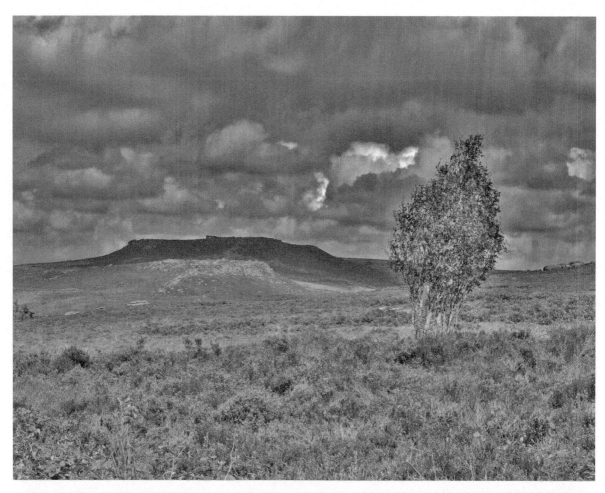

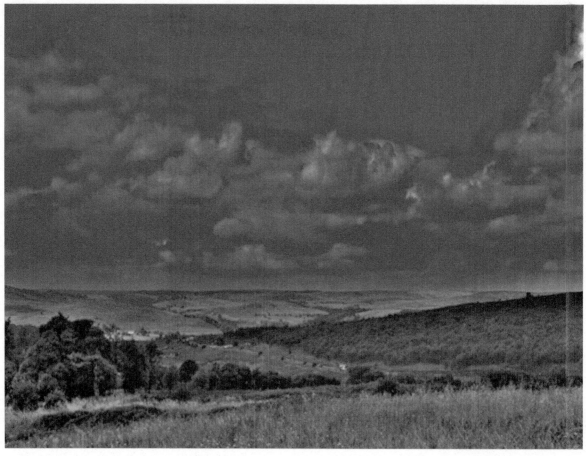

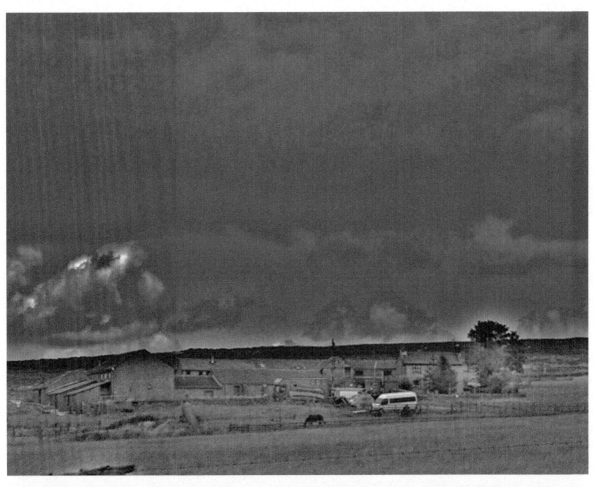

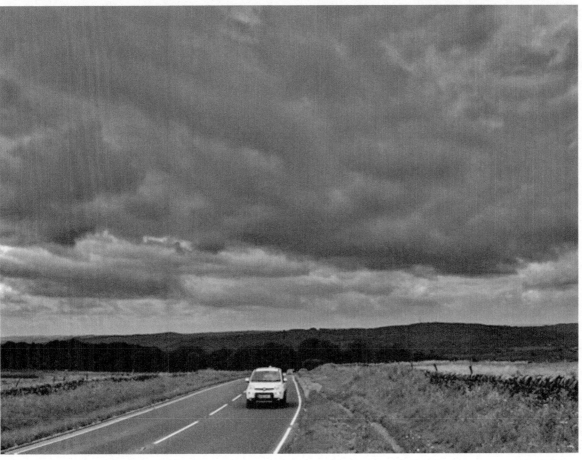

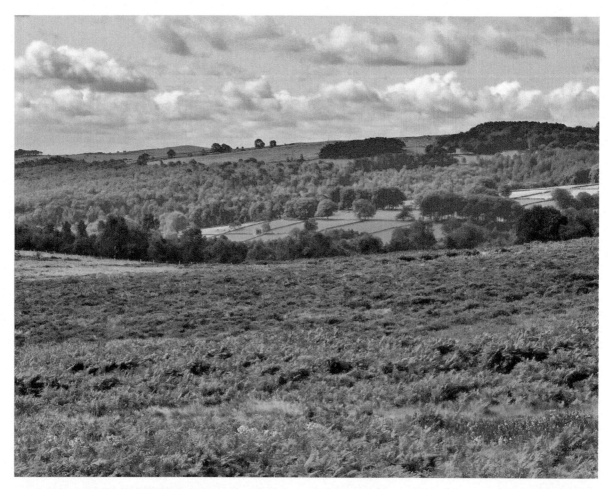

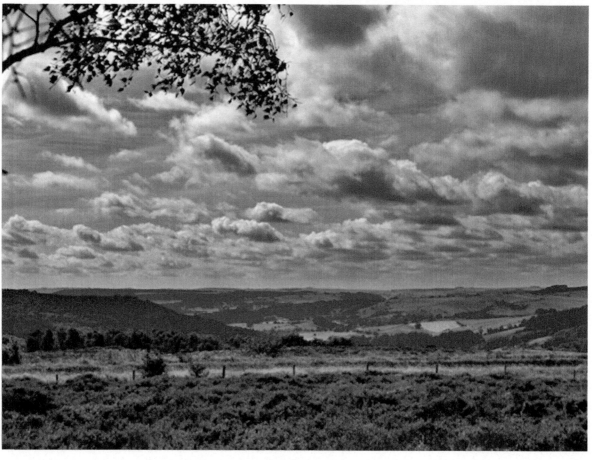

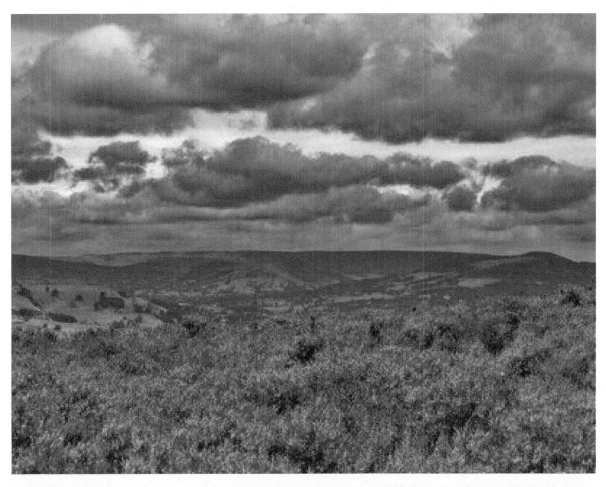

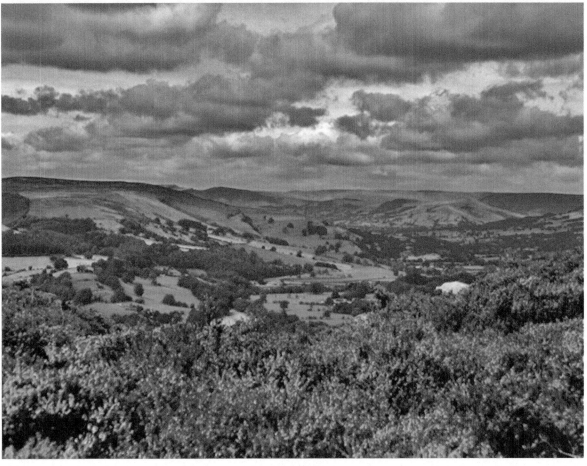

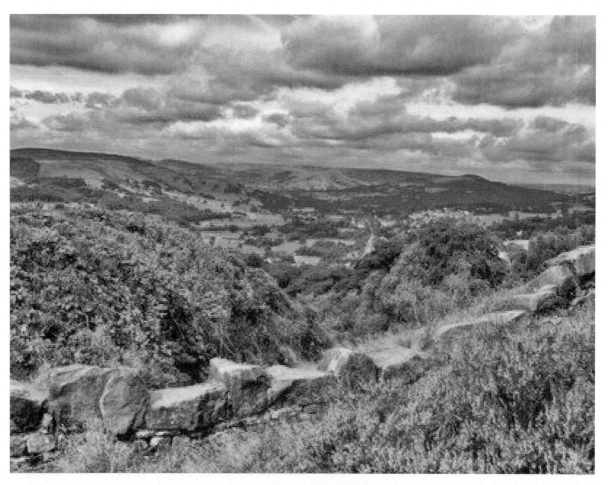

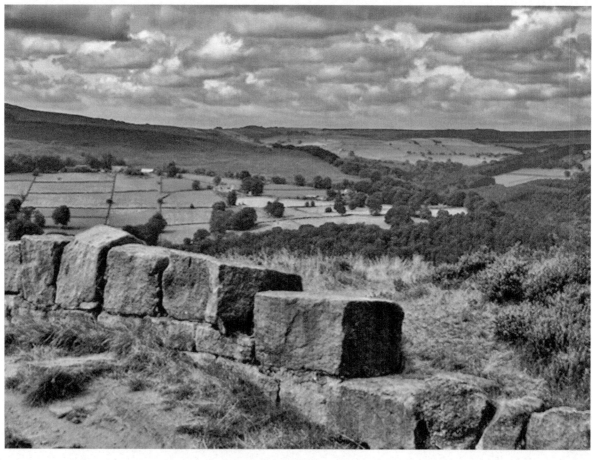

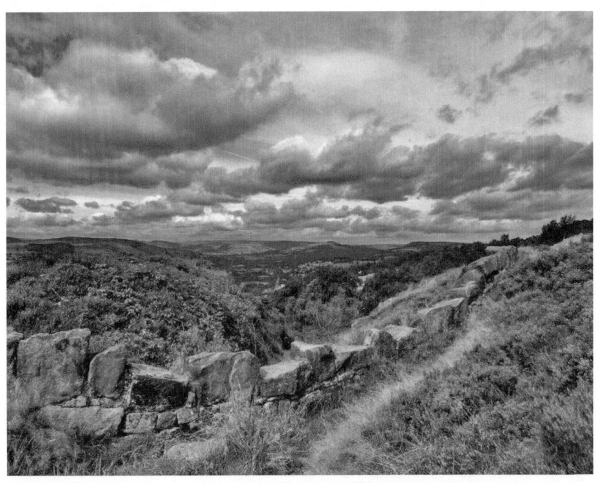

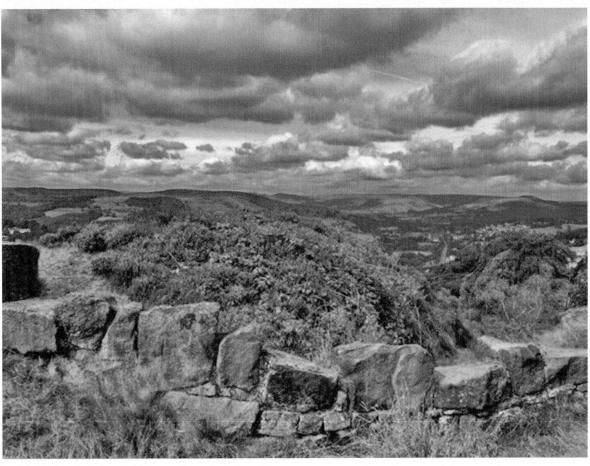

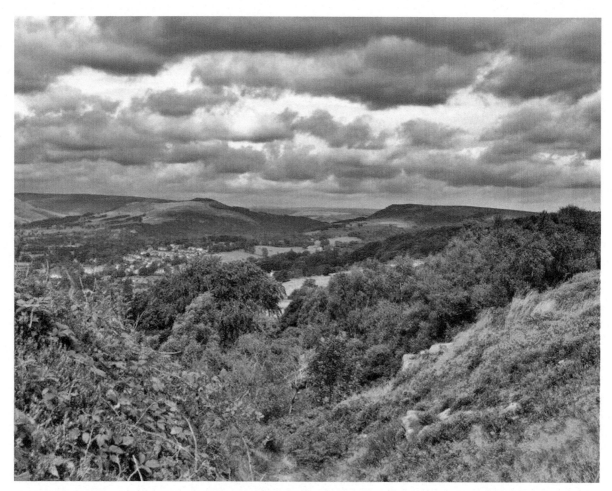

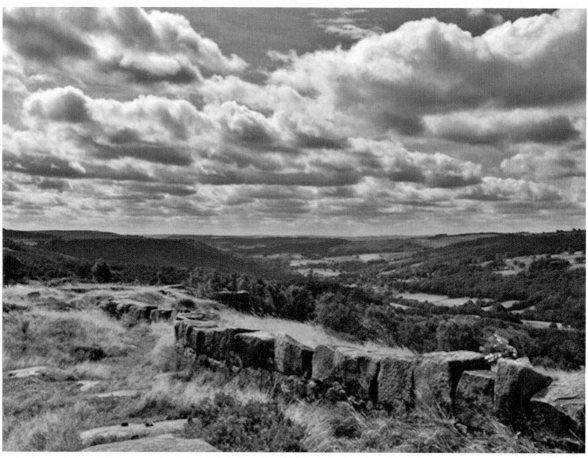

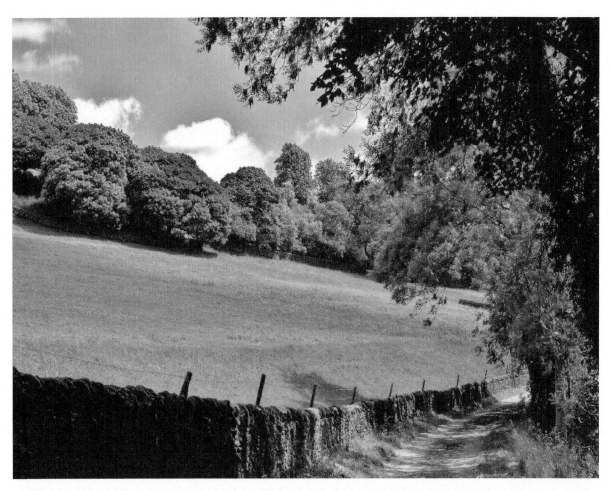

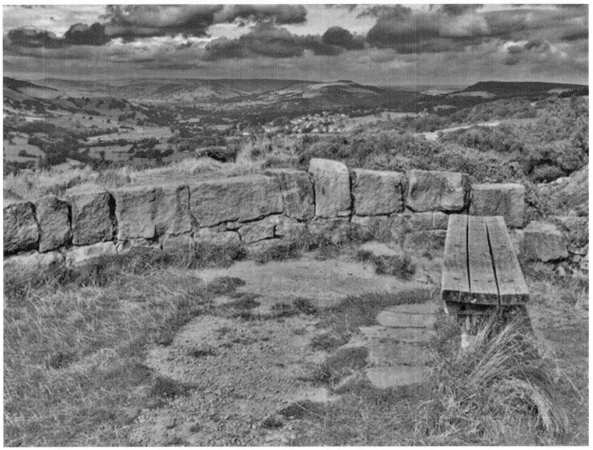

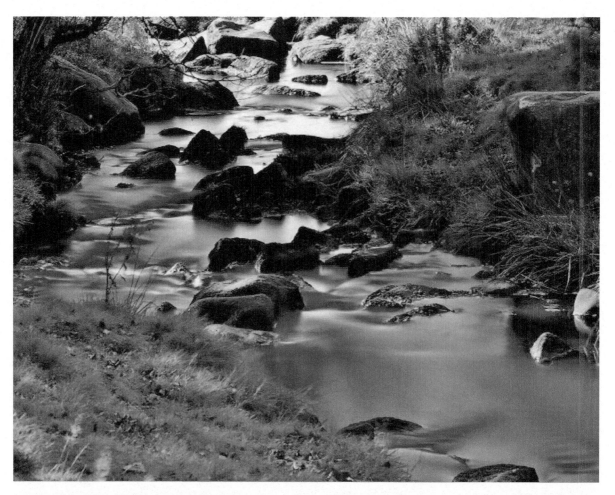

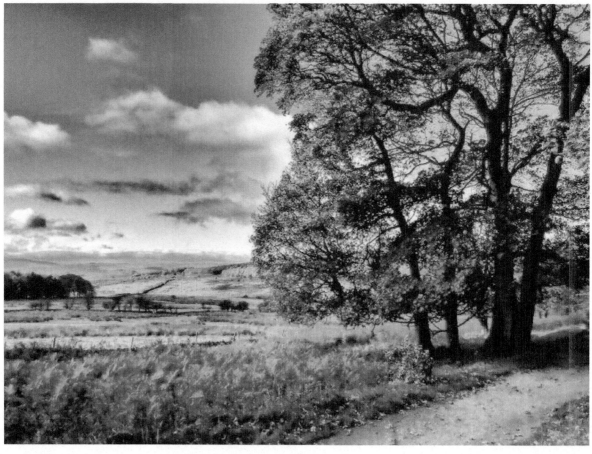

[41]

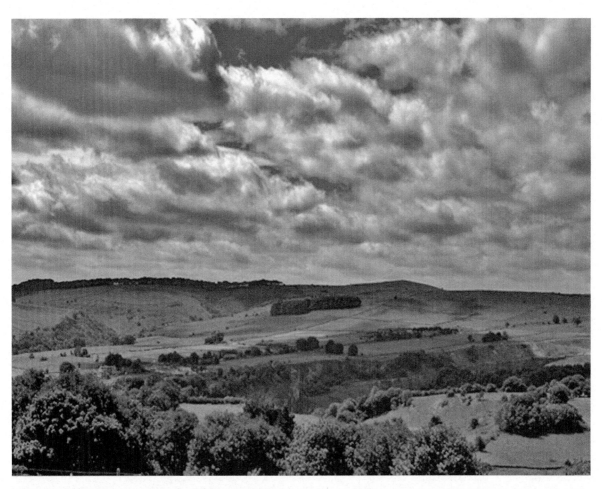

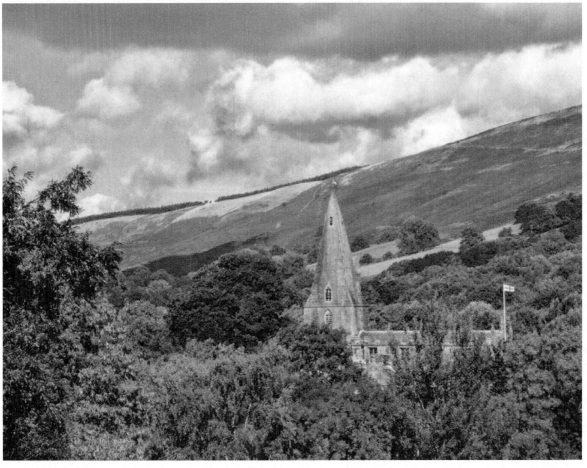

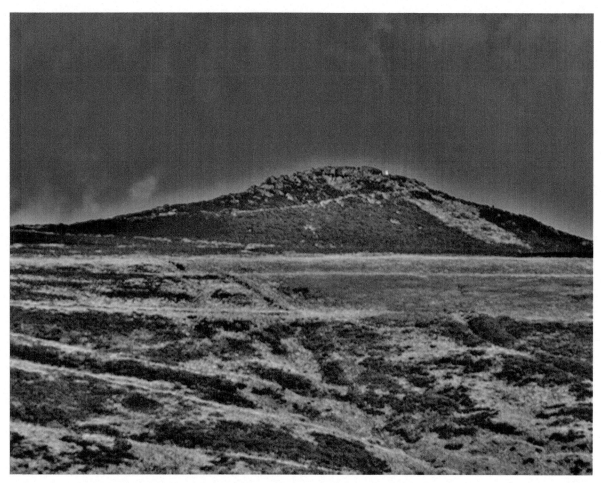

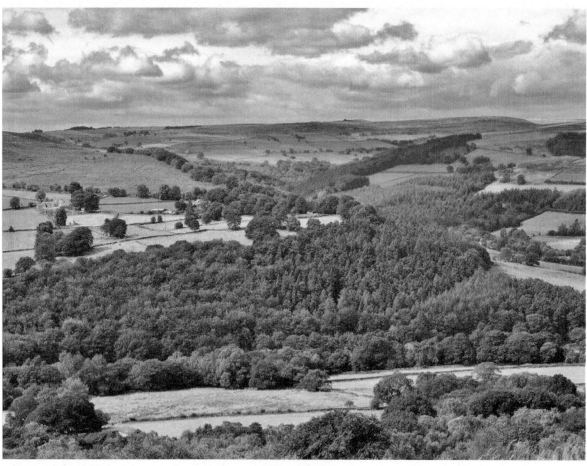

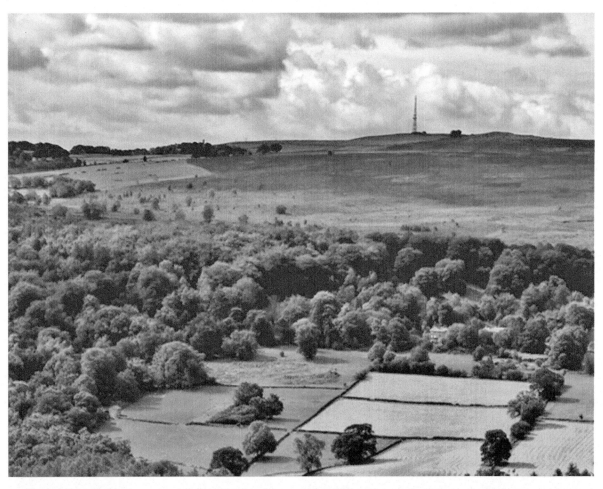

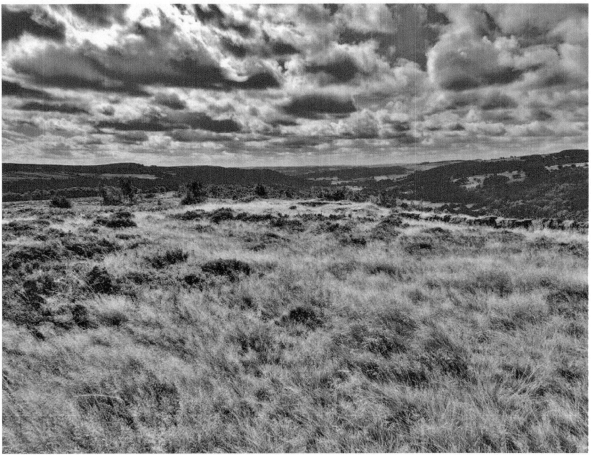

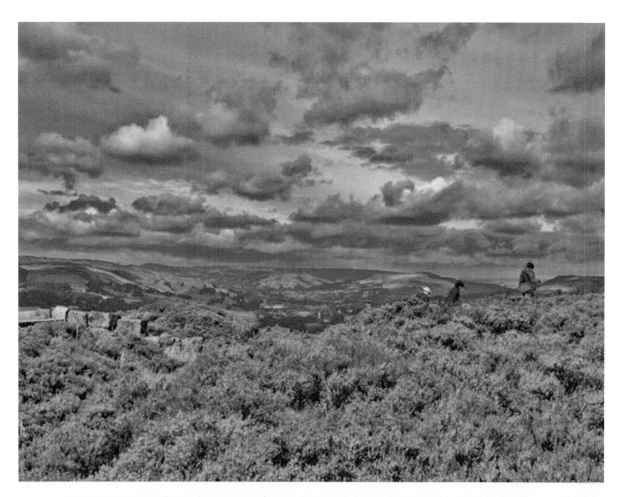

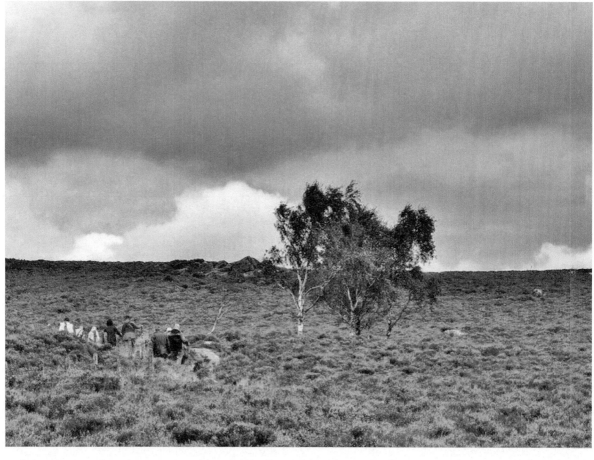

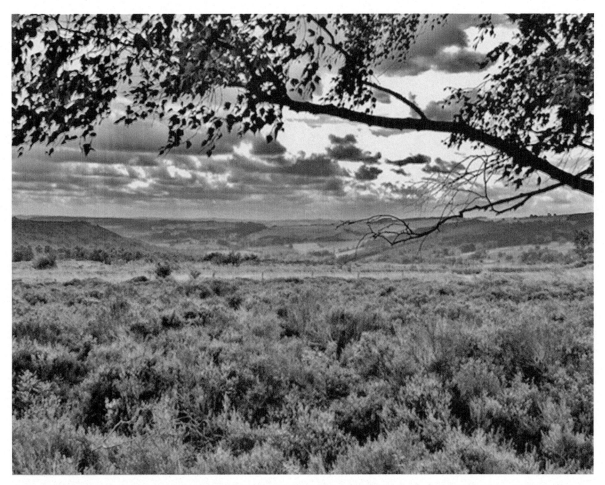

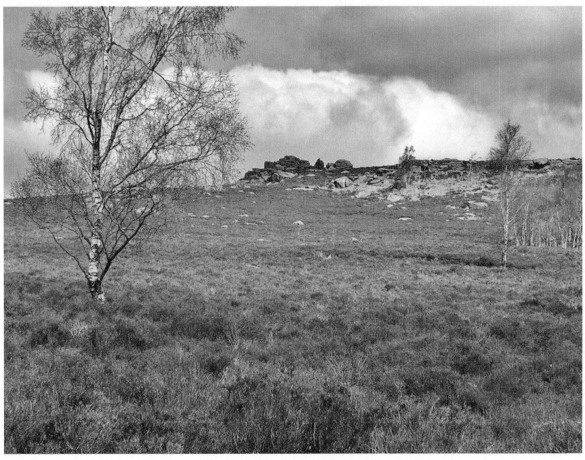

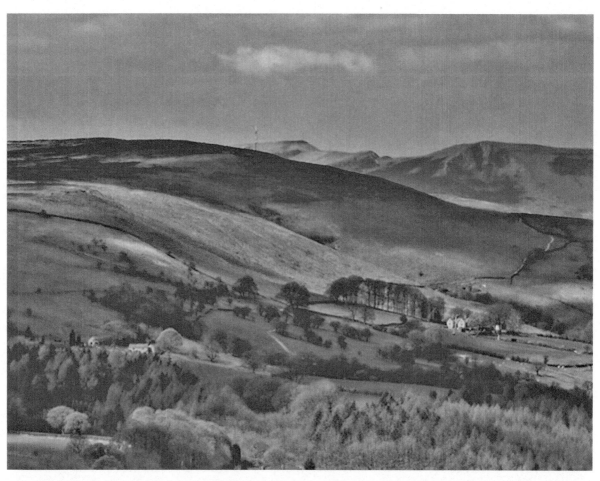

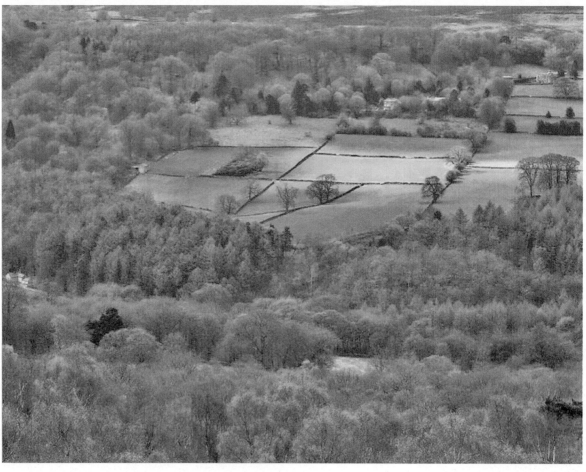

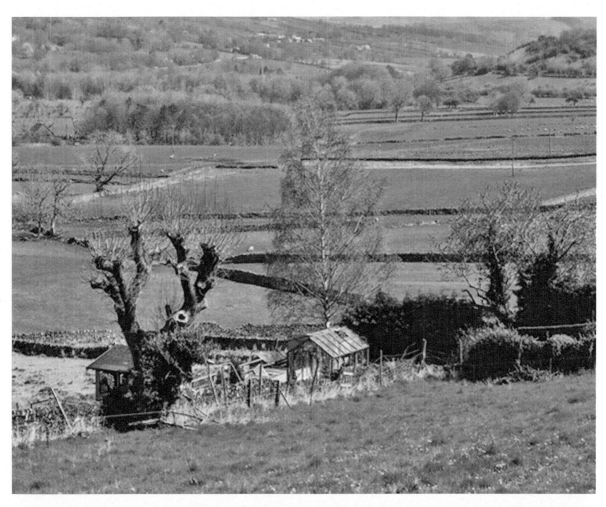

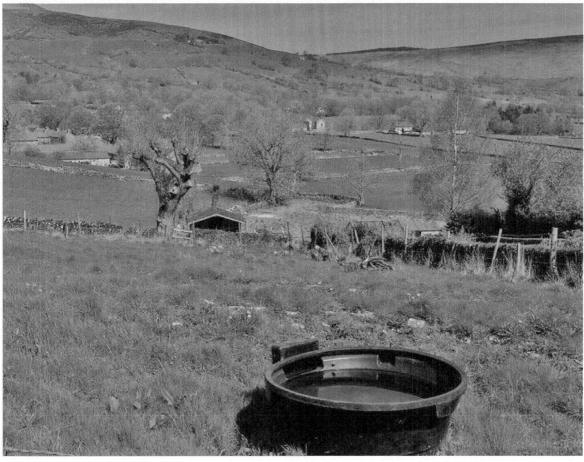

[48]

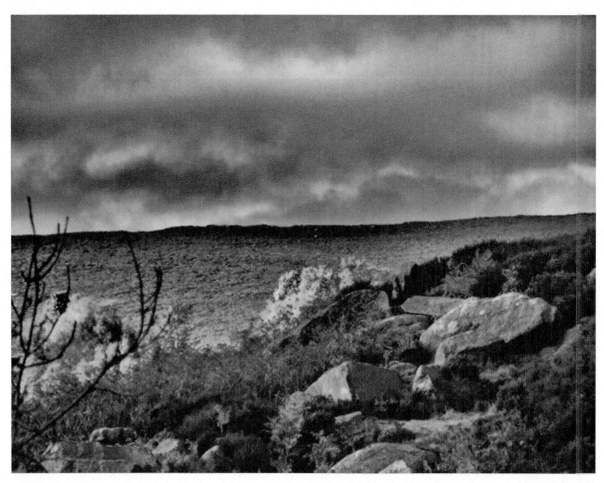

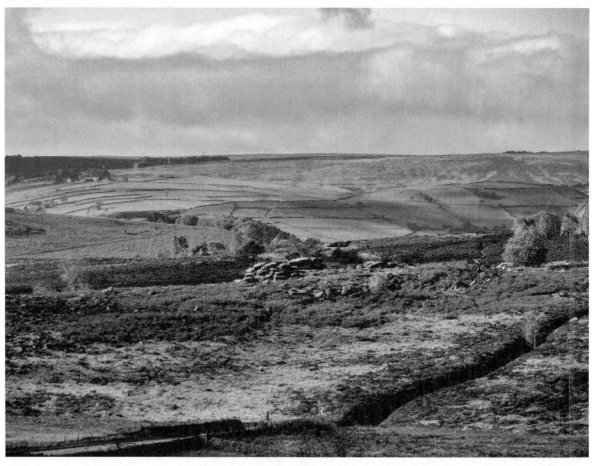

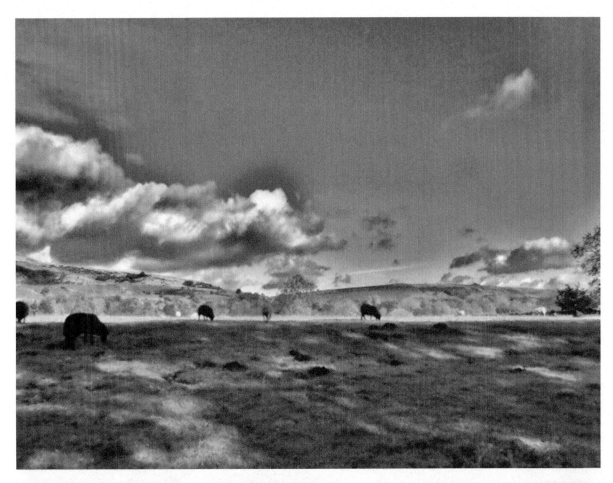

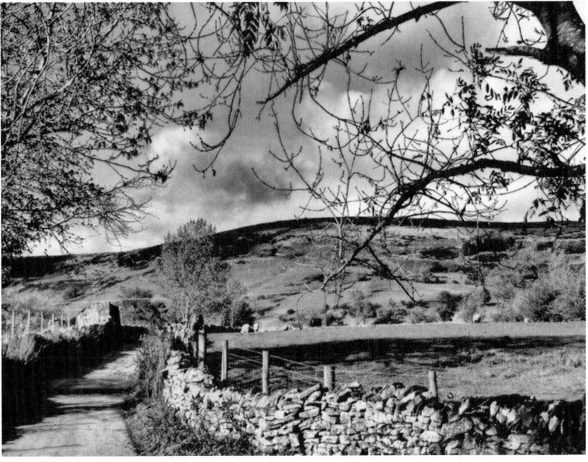

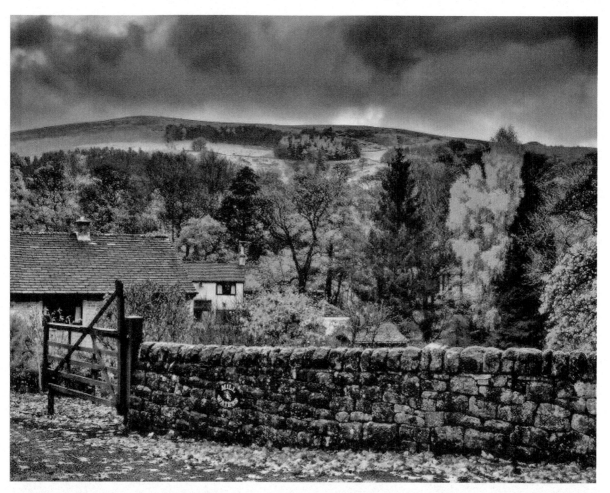

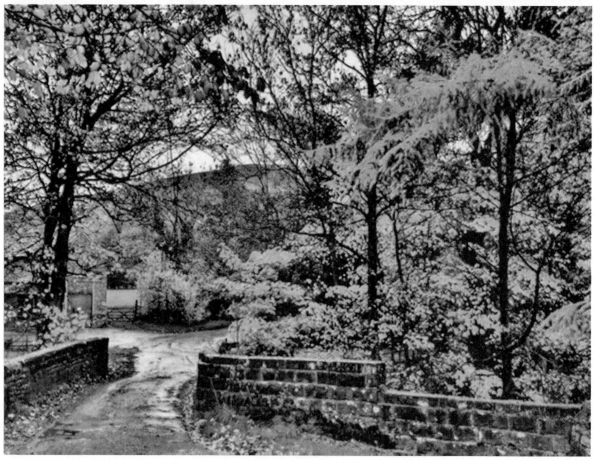

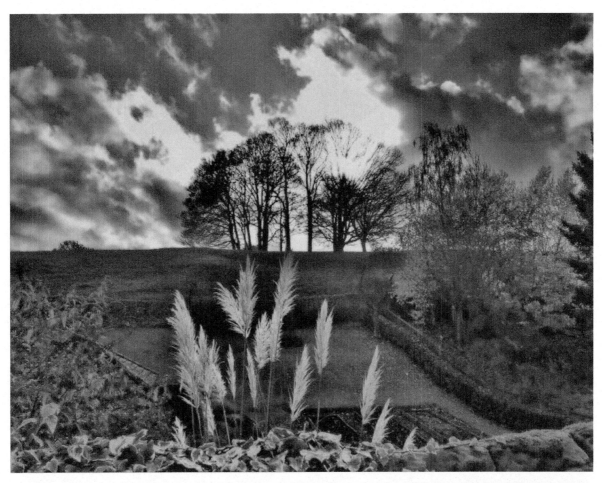

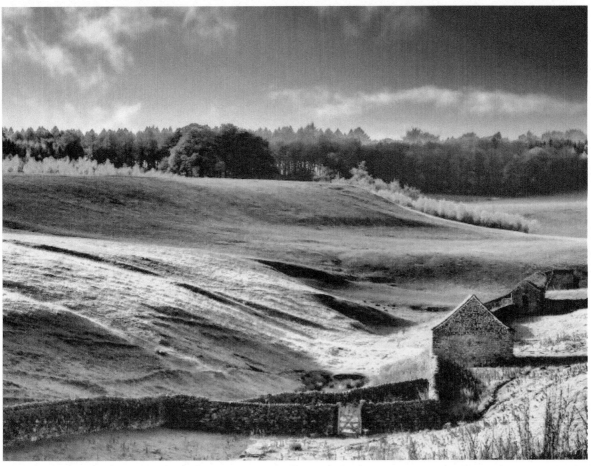

[52]

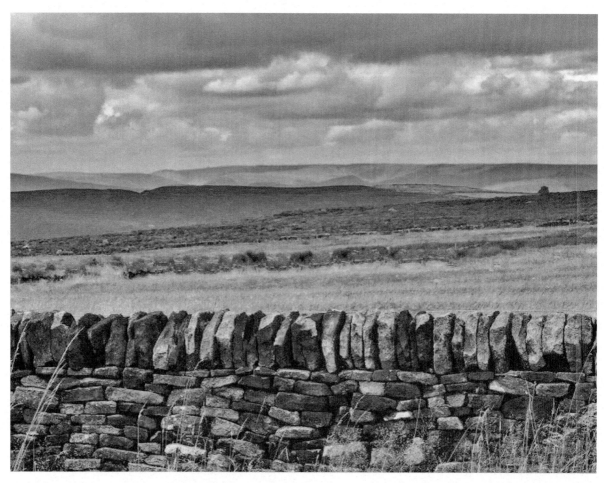

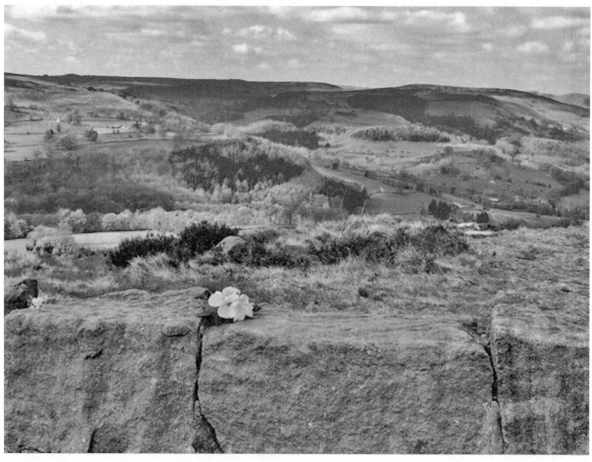

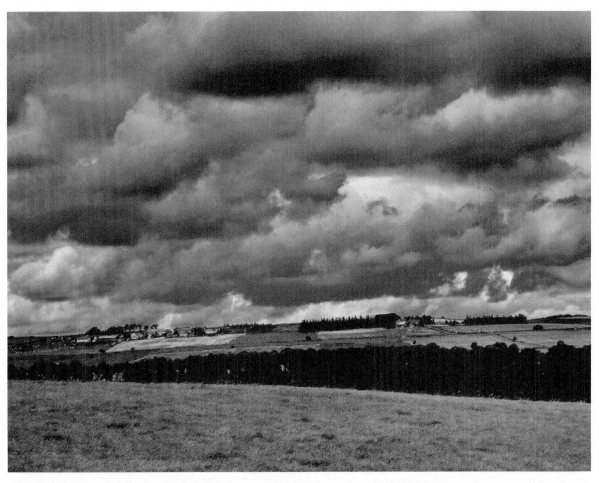

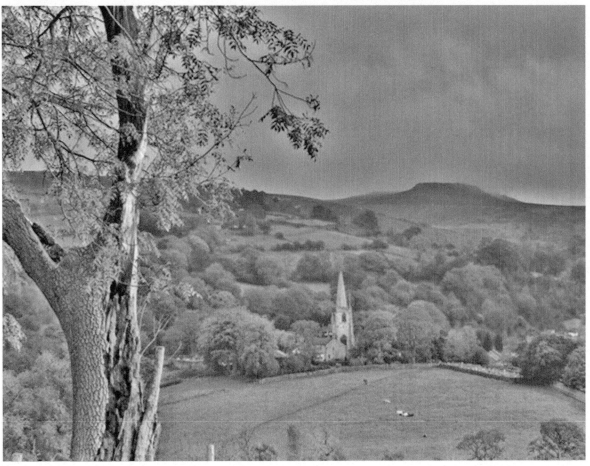

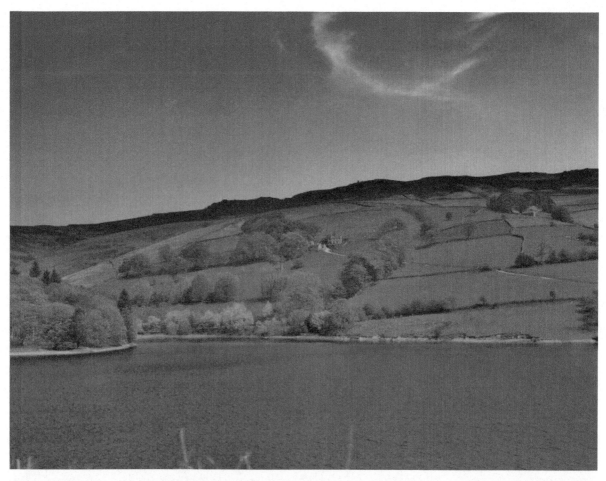

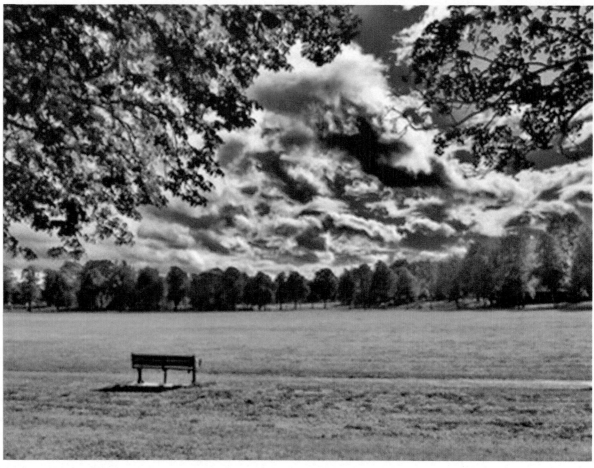

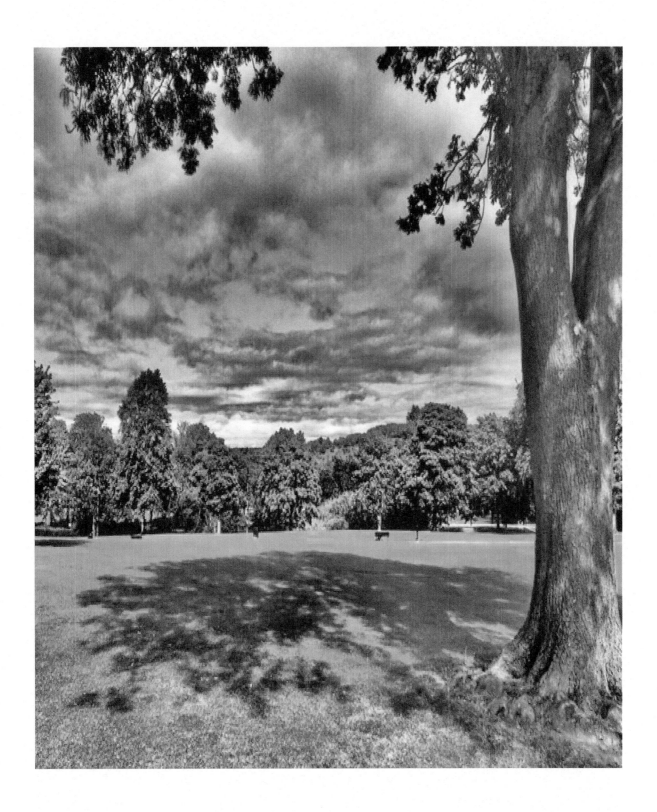

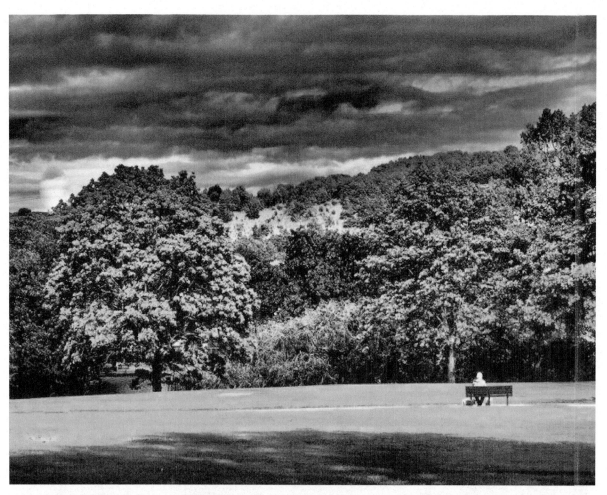

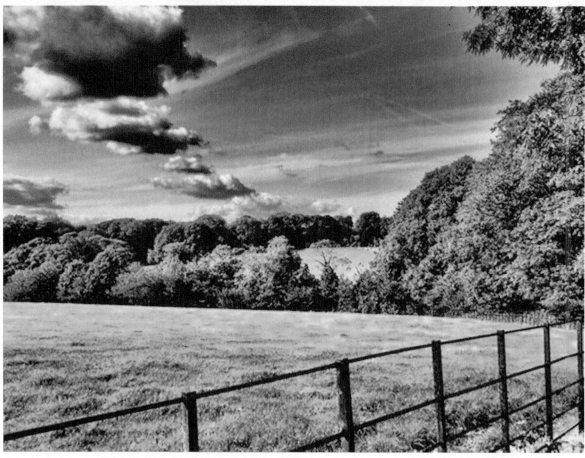

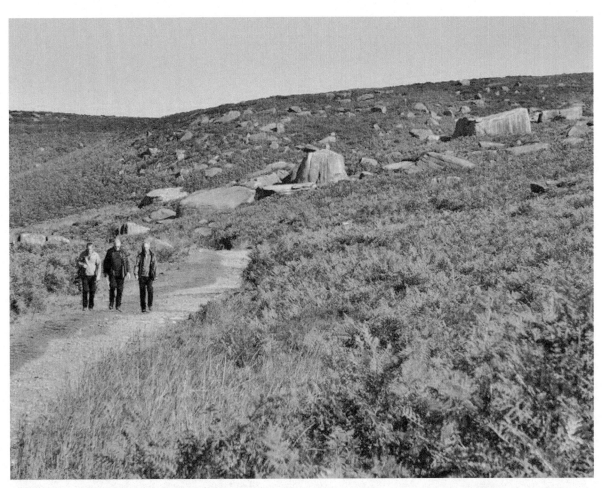

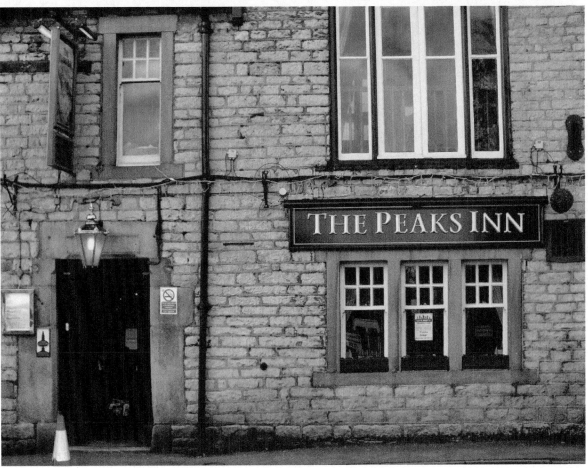

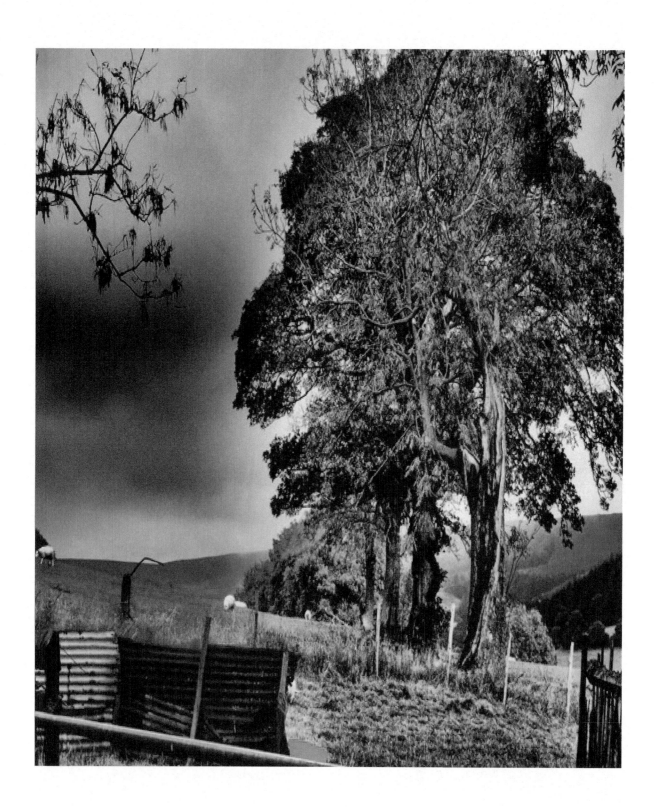

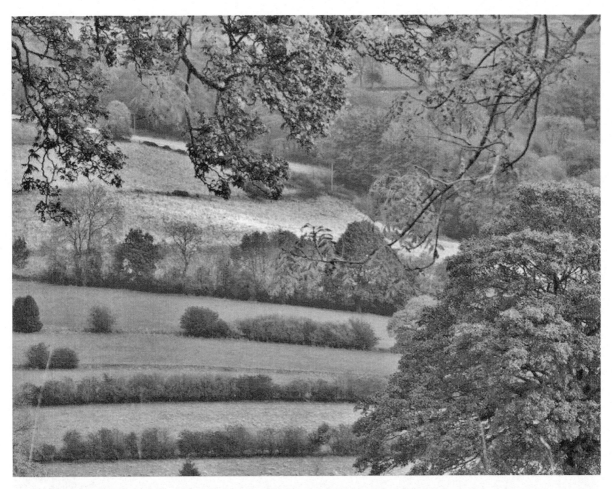

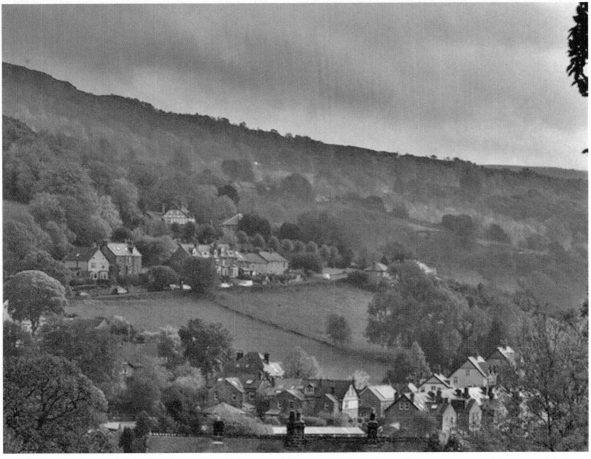

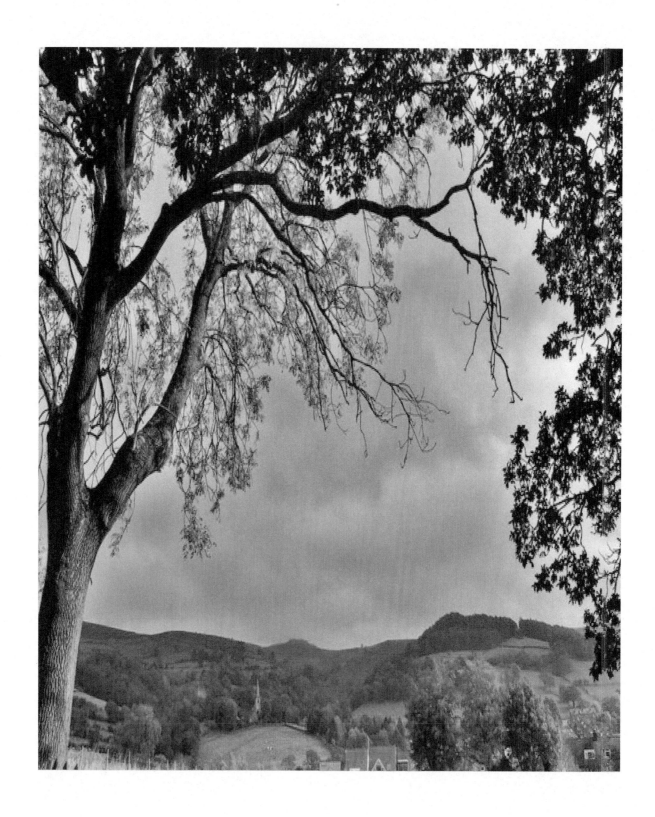

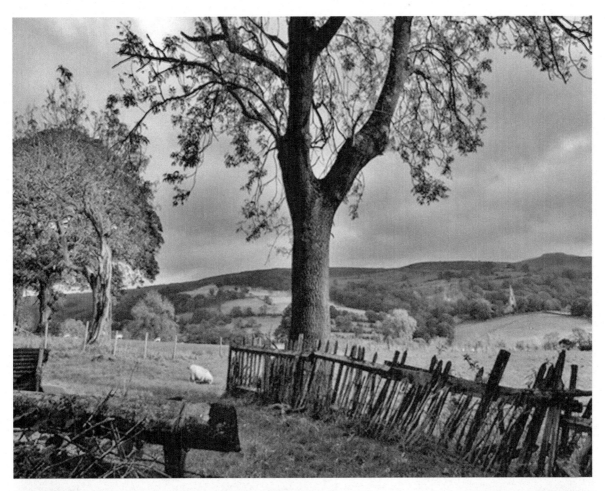

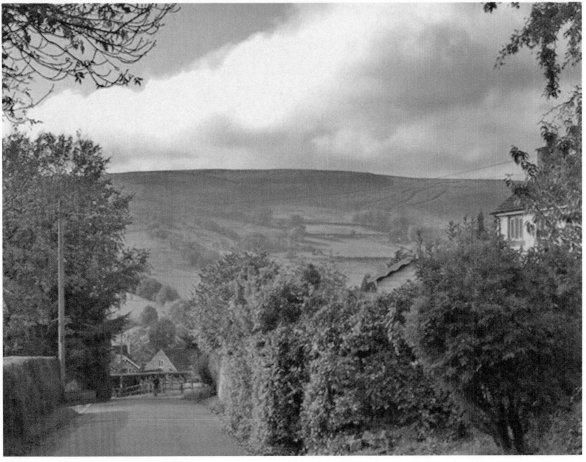

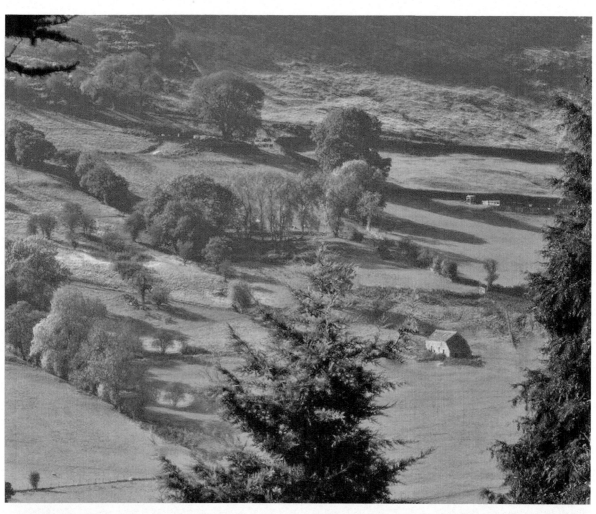

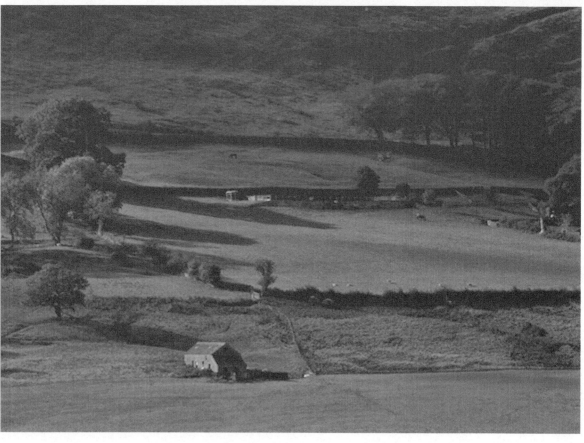

[63]

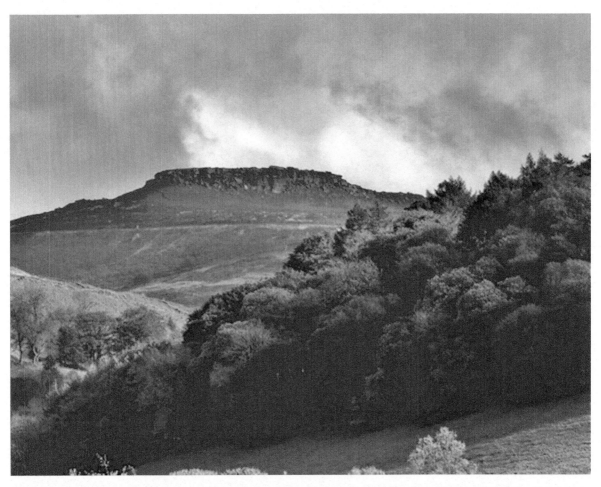

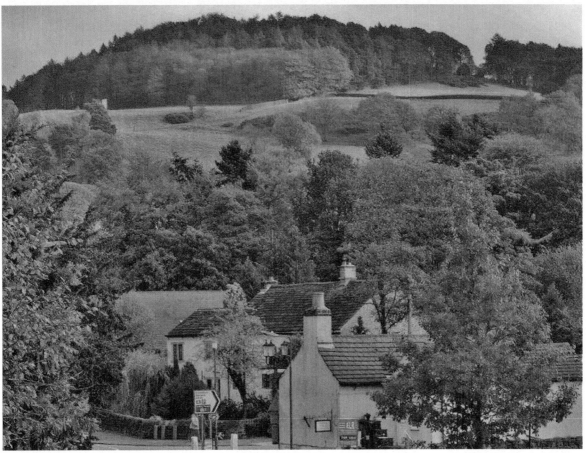

[64]

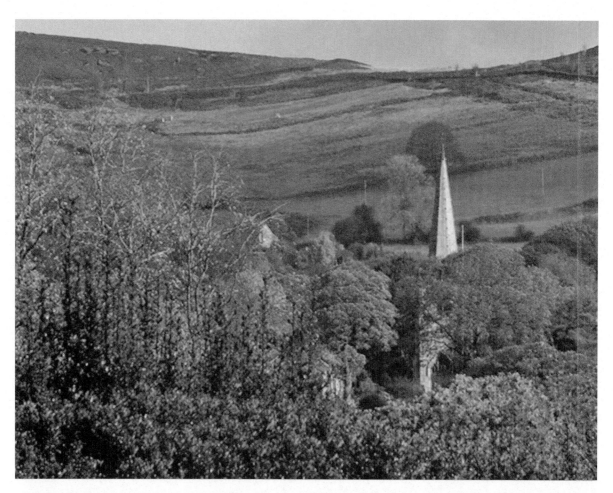

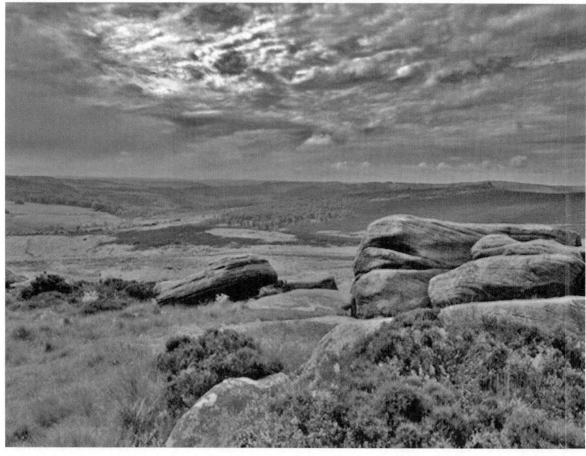

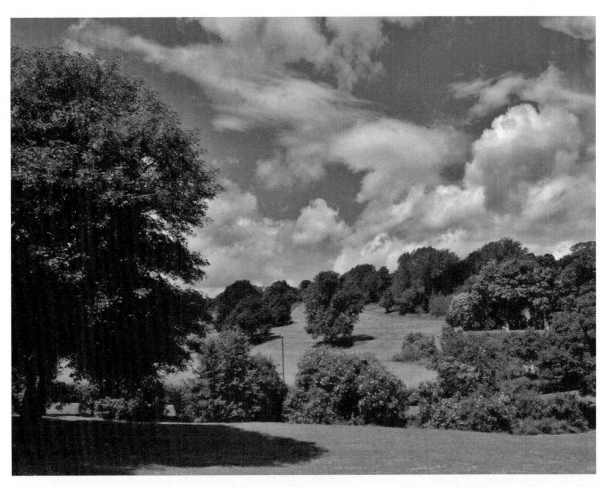

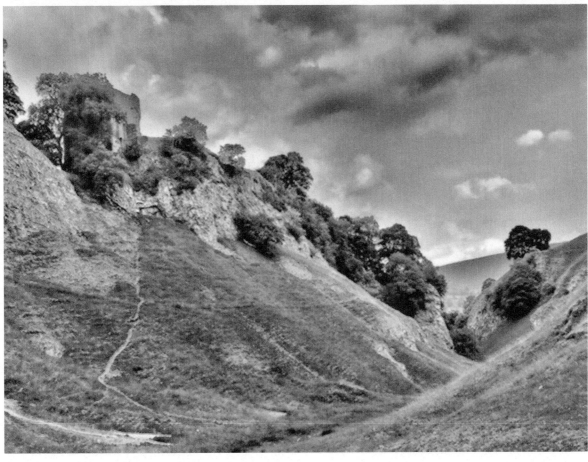

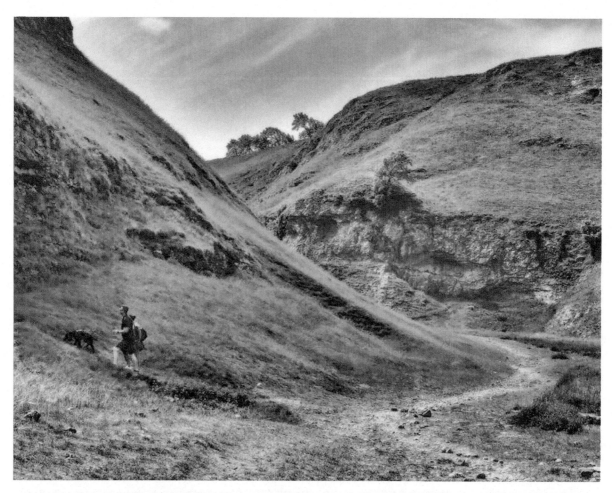

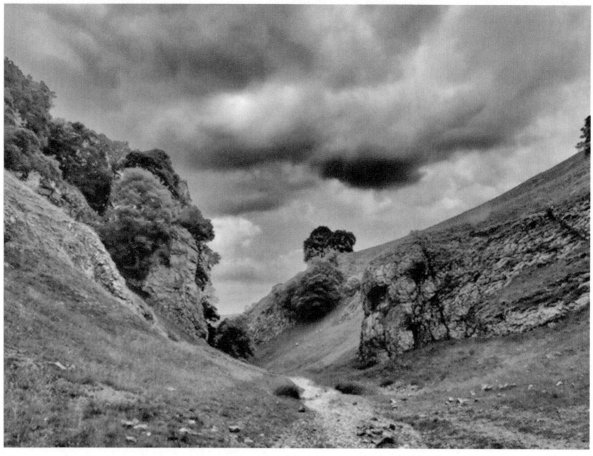

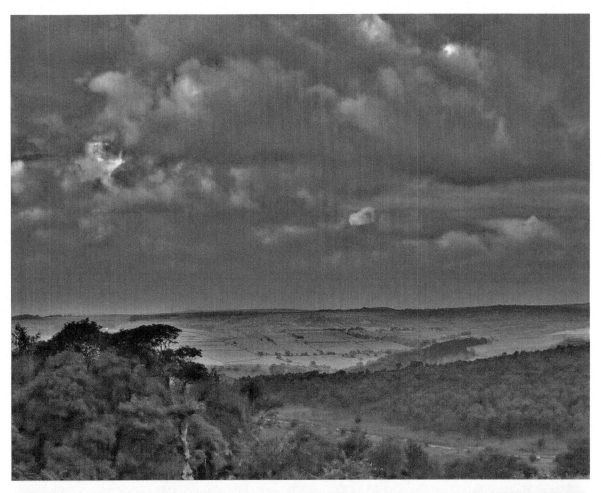

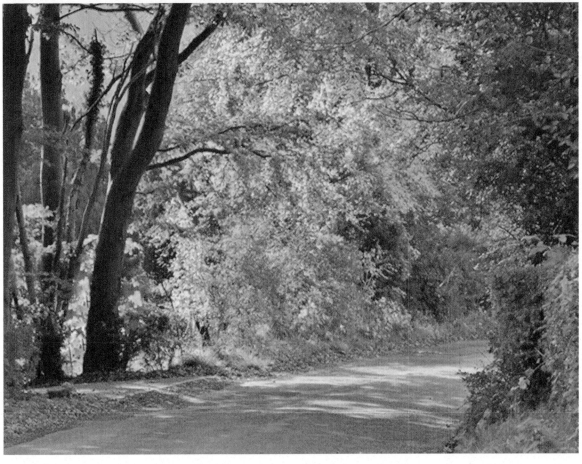

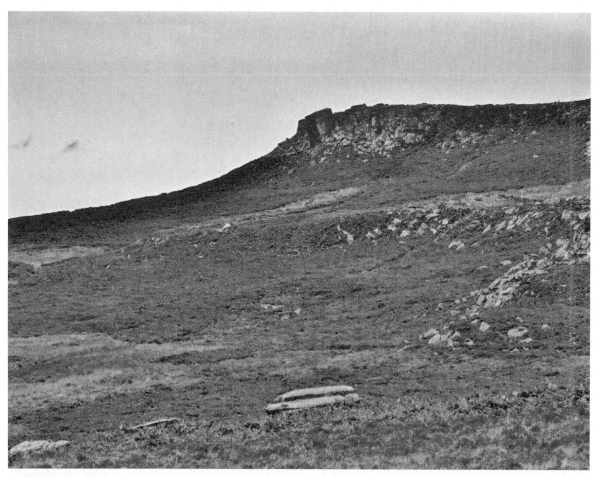

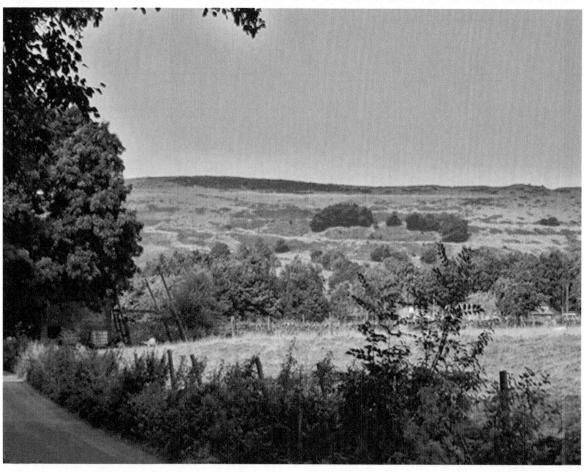

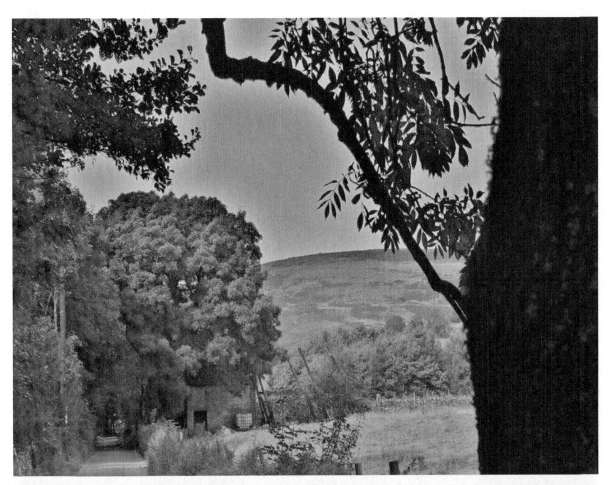

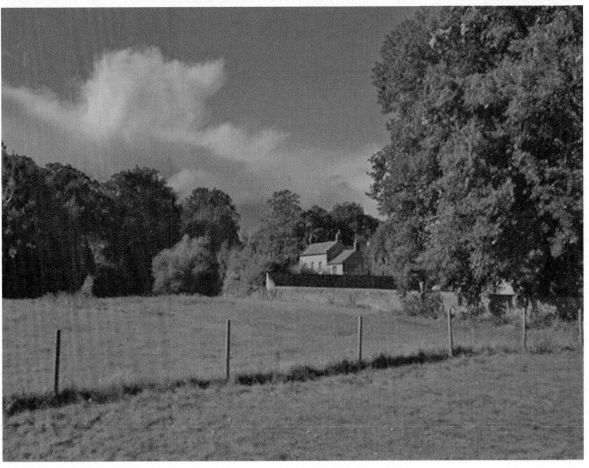

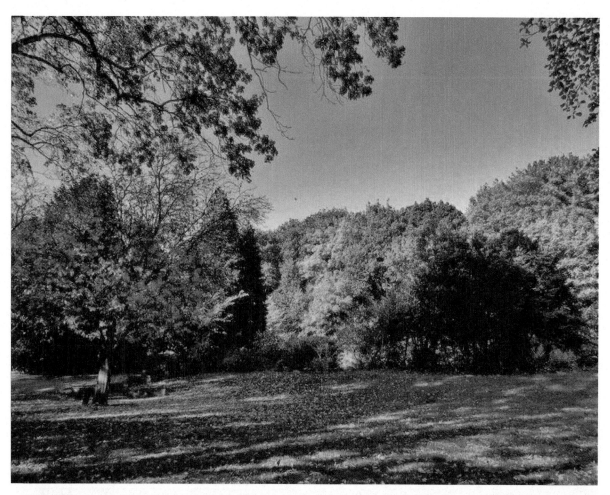

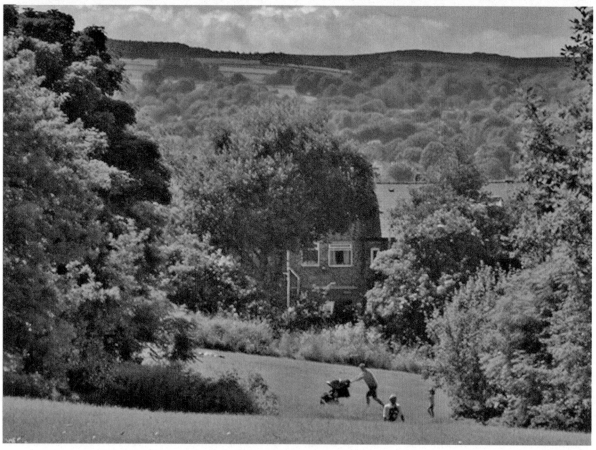

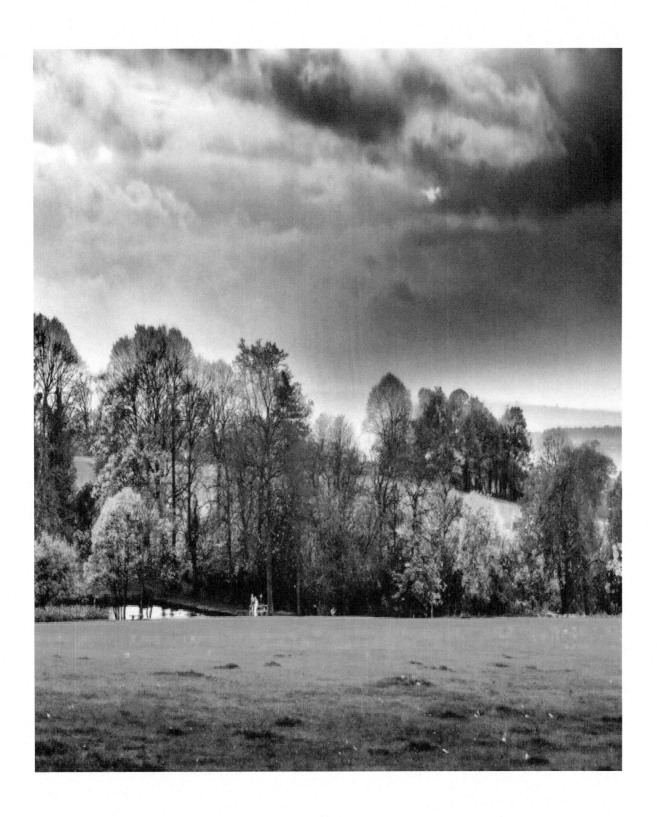

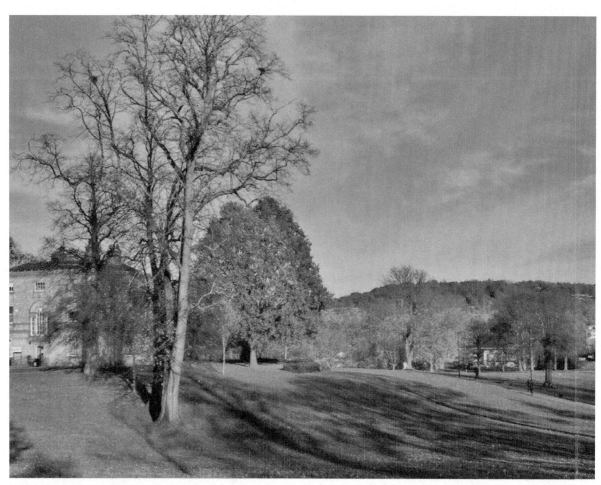

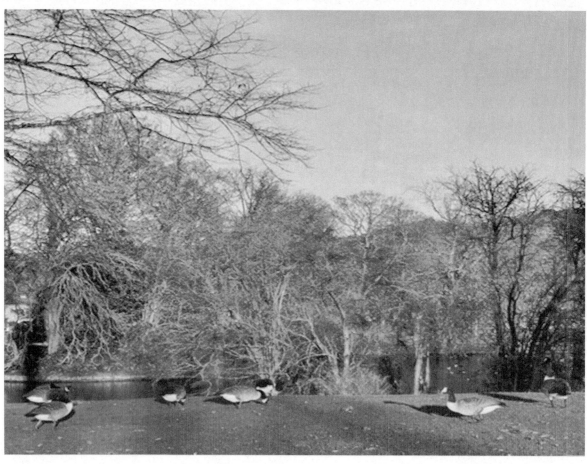

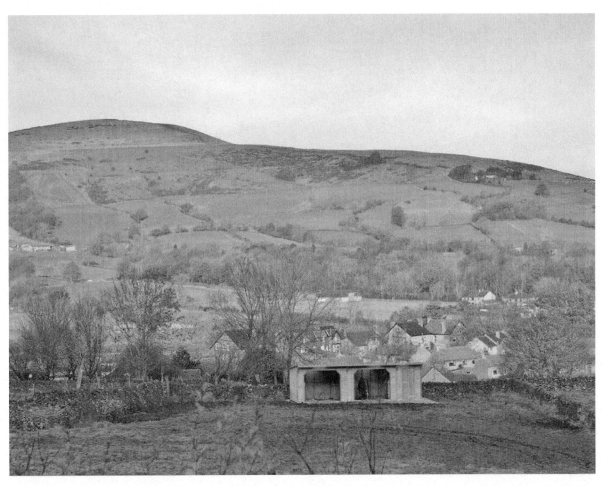

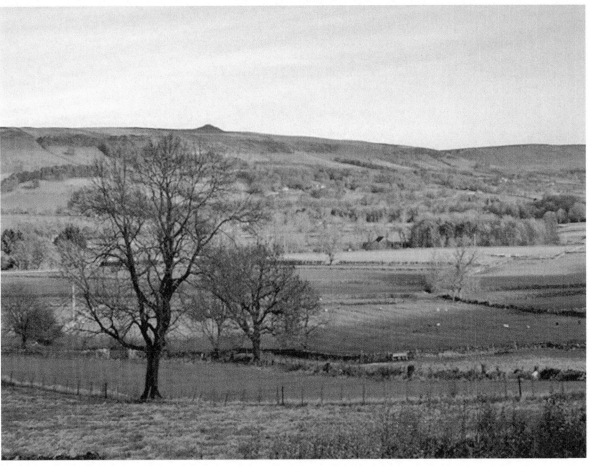

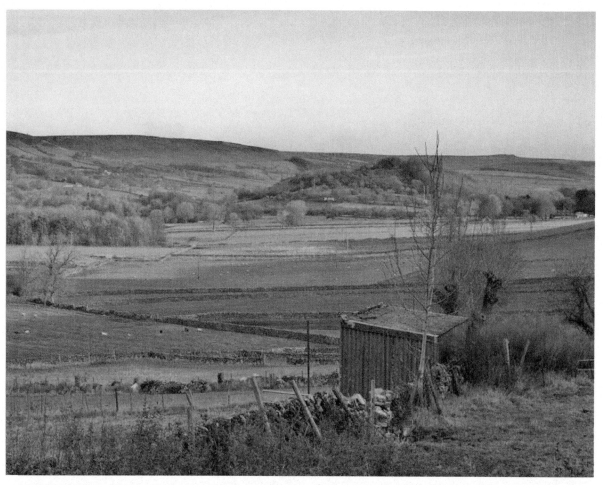

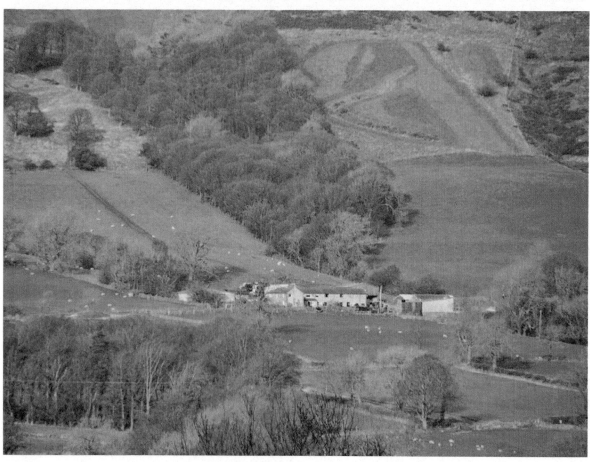

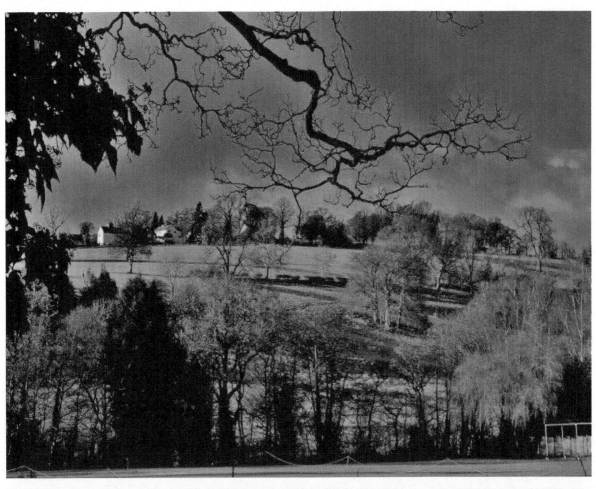

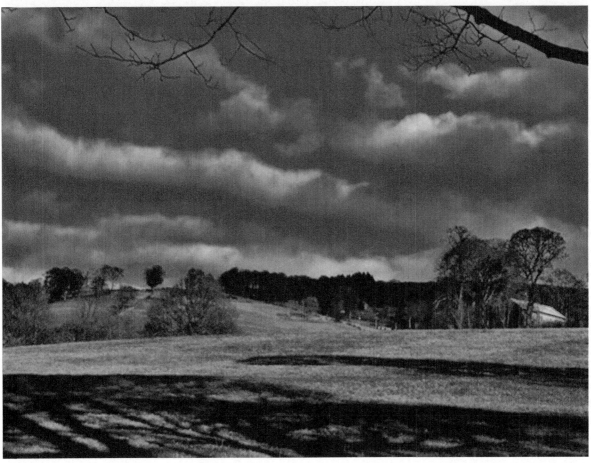

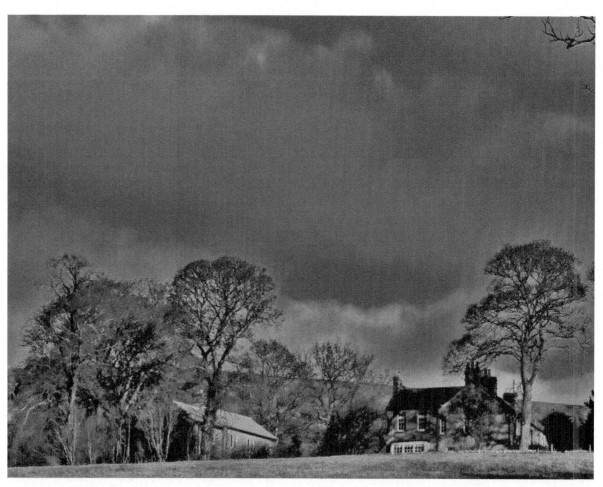

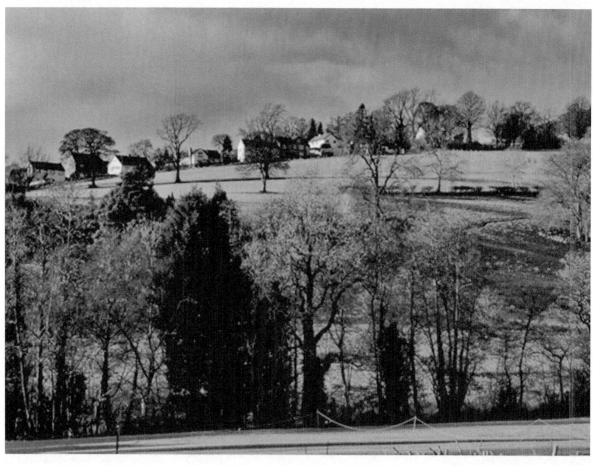

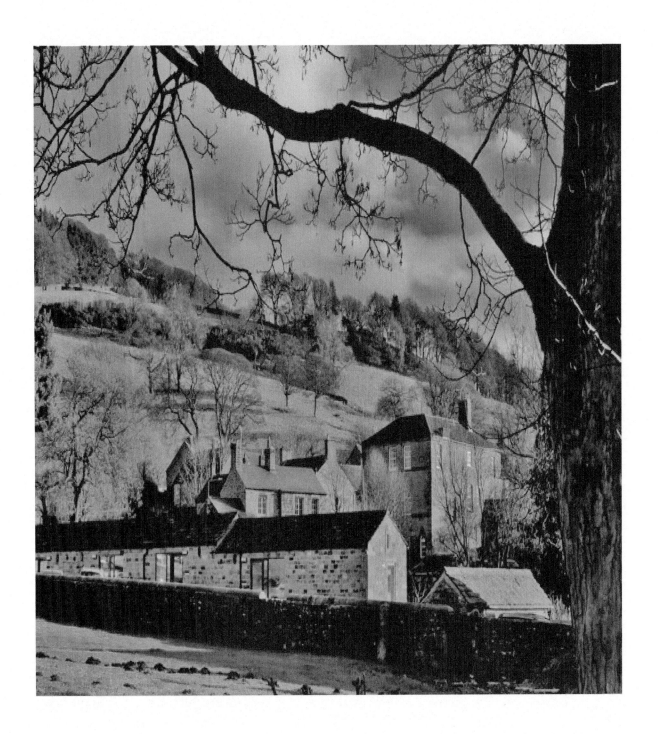

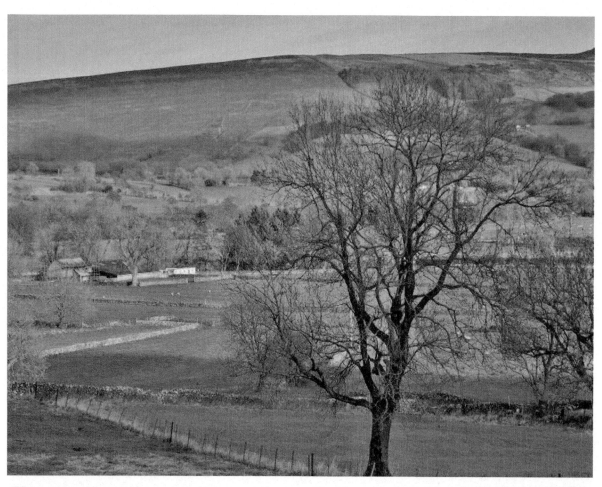

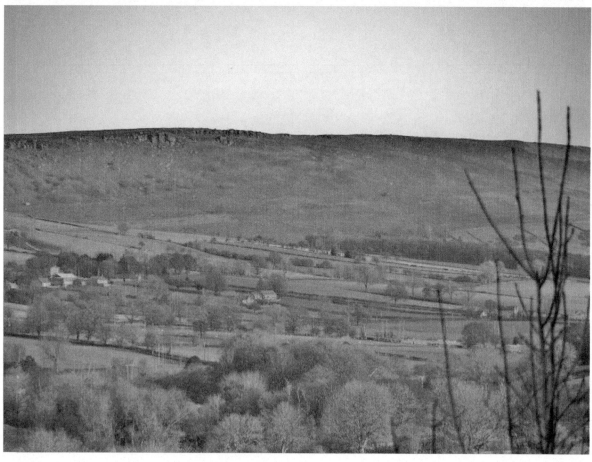

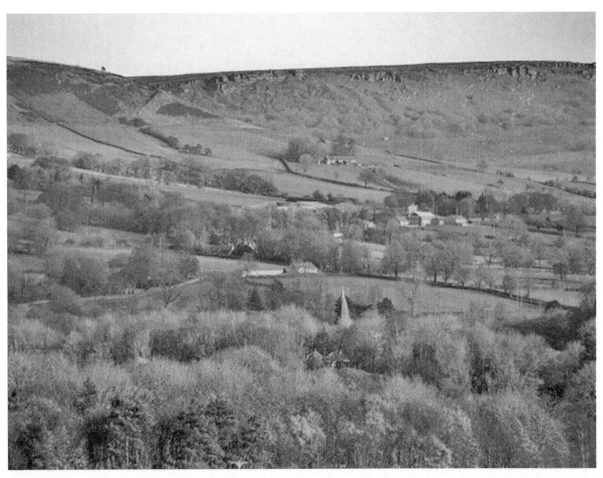

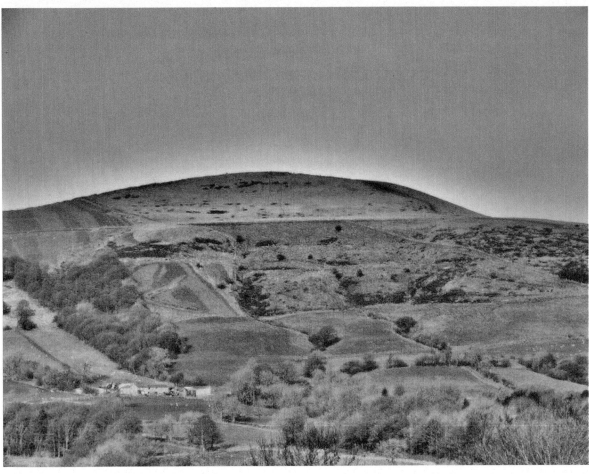

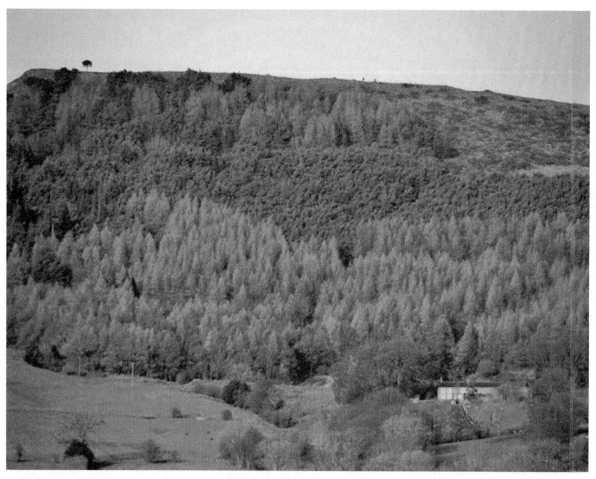

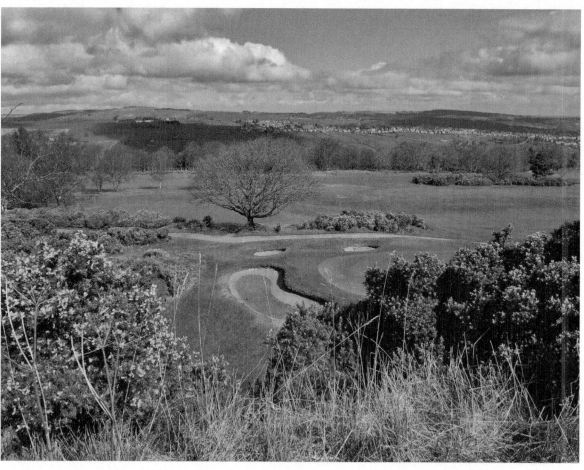

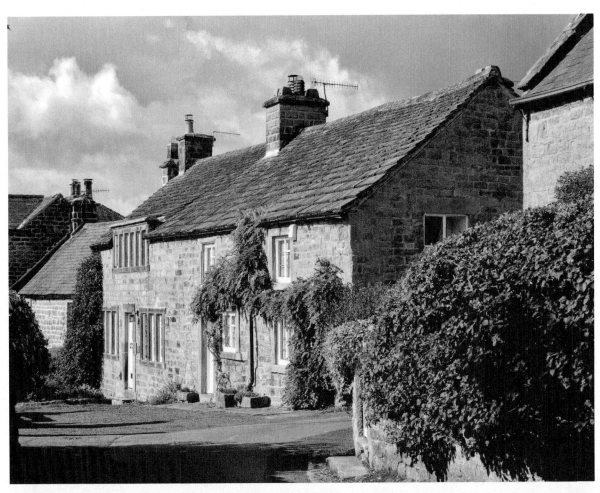

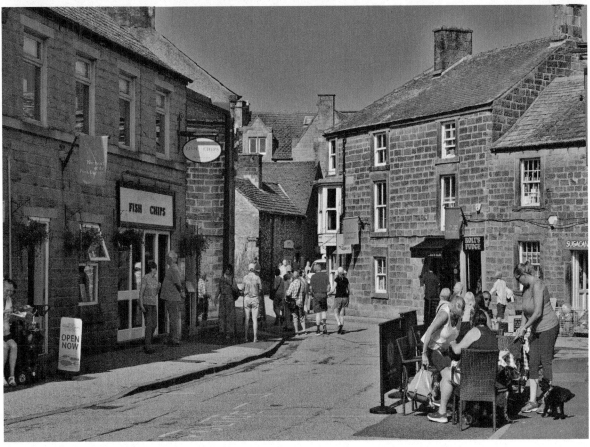

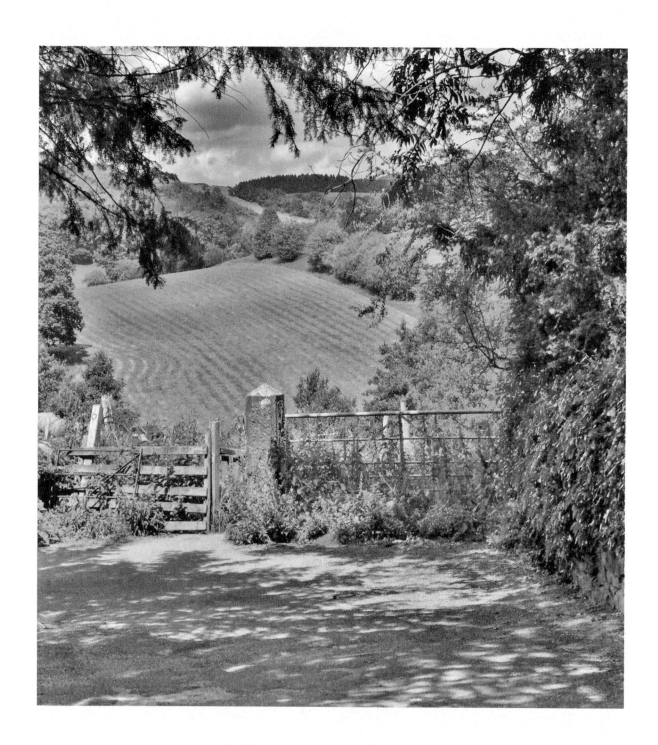

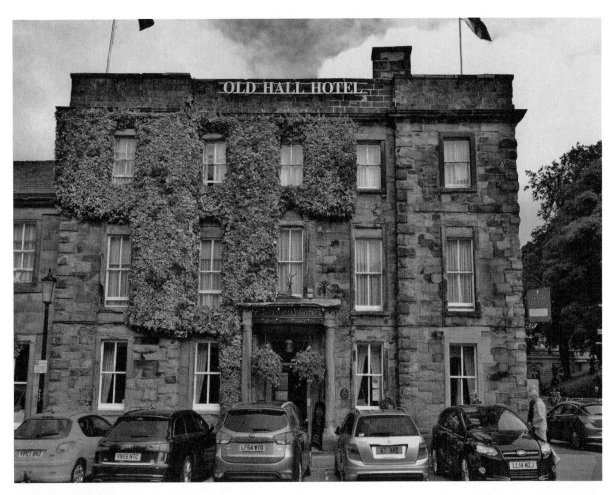

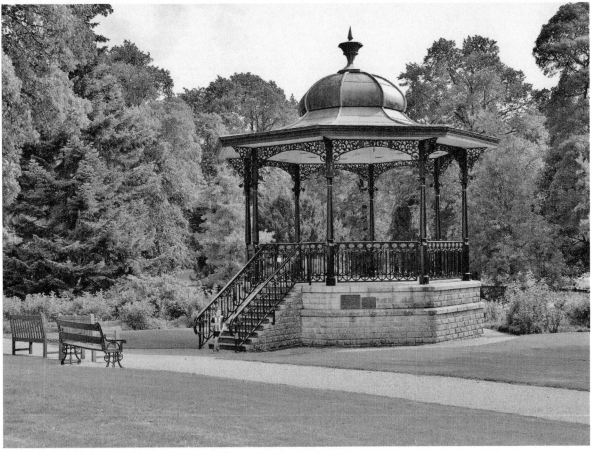

[84]

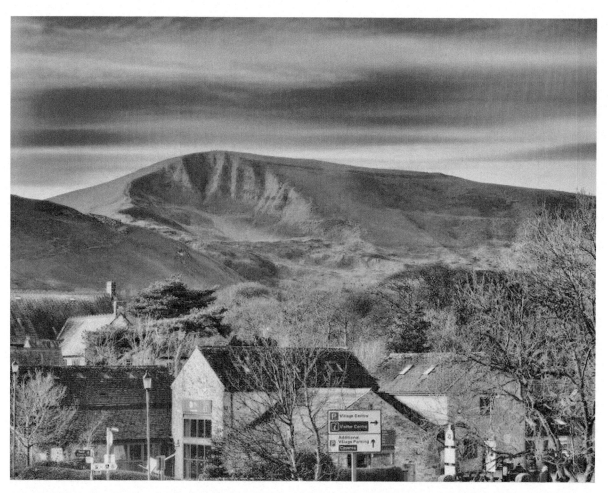

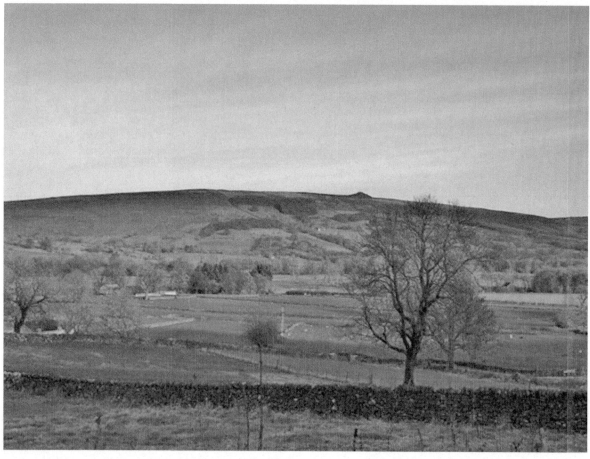

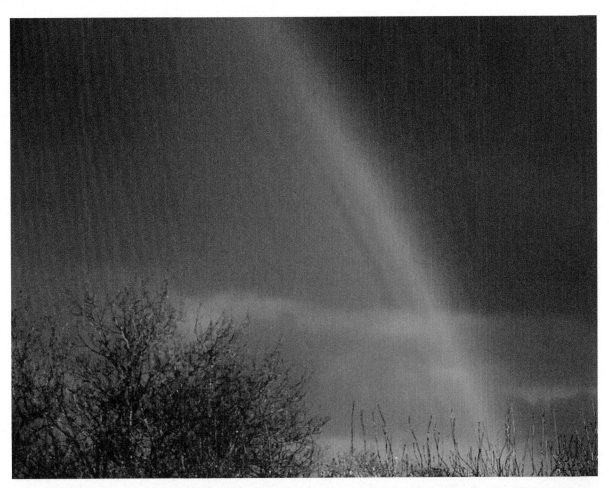

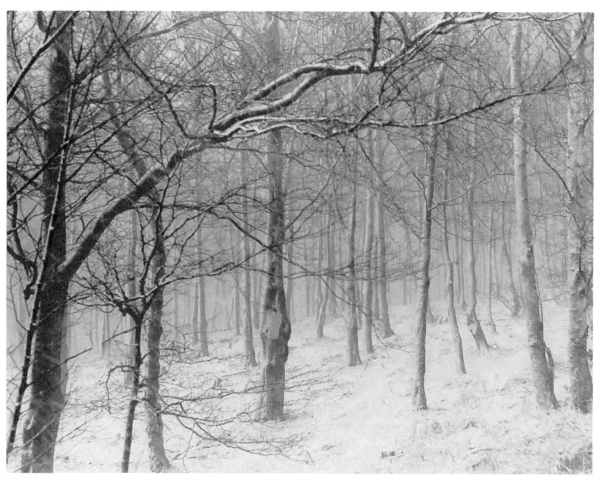

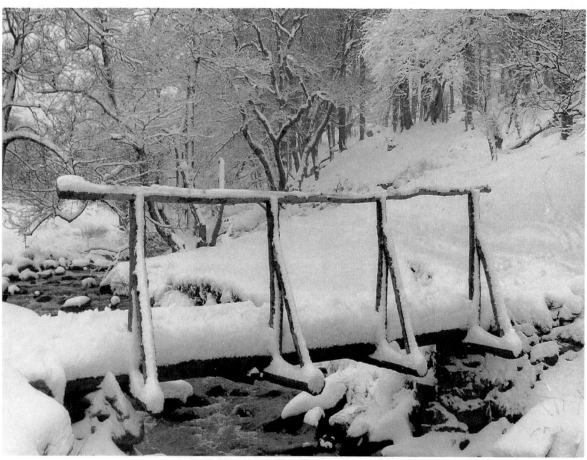

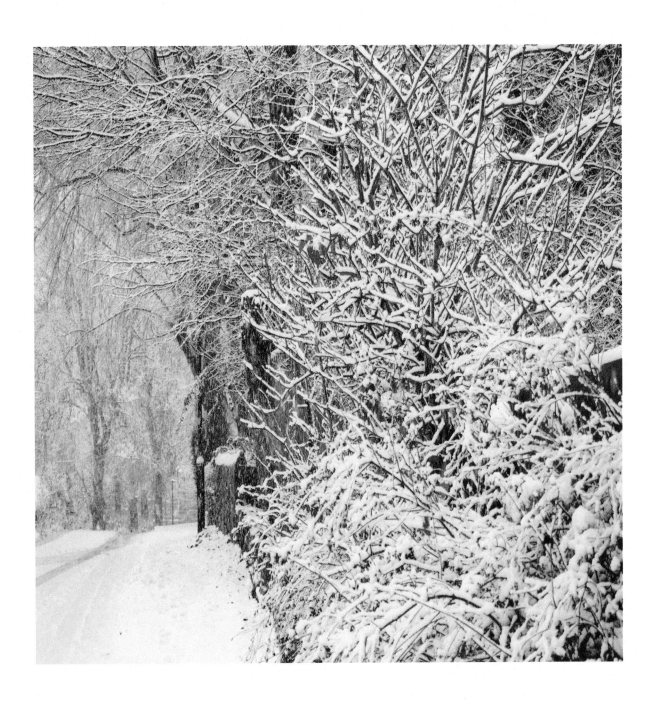

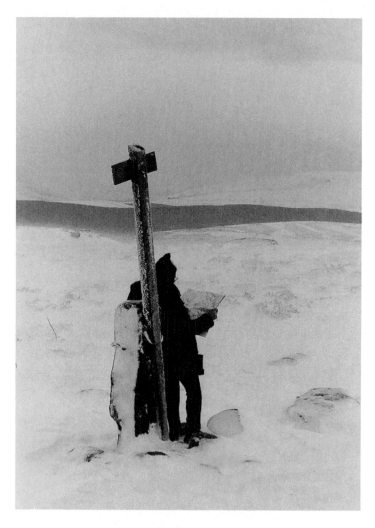

Dedication:
In memory of my 1960s walking companion,
Heyward Aubrey Robert Frith, 1927 - 2003.

Acknowledgements

I would like to thank Editor Colin Meek for bringing this book into being and all the hard work he's put into its creation and publication.
Some of these photographs have appeared on Facebook and Instagram and on the photo-sharing websites - 500px, Viewbug and Tumblr.'

David Norris-Kay
2022

Author

David Norris-Kay - David was christened David Austin in 1949, and adopted his writing name with the encouragement of his friend and fellow poet the late Margaret Munro-Gibson (Margaret Hoole) who wrote under her Grandmother's and Mother's maiden names. David now does the same. He started writing poetry in 1967, inspired by Simon and Garfunkel's lyrics. His poetry is lyrical and a lot of it is written in traditional forms, although he also writes in free verse. His free verse poem, 'Butterfly' won first prize in the Salopian Poetry Society's competition in 1981, and his poem 'Autumn's Reflection' won the third prize of £250 in Forward Poetry's competition in 2004. David is divorced and lives happily on his own in Sheffield, Yorkshire, England.

He is inspired by his happy 1950s childhood, the natural world, (Especially The Peak District National Park) and his friend's children. He writes mostly poetry, although his 4000 word, supernatural short story 'The Moss Garden' was published twice in 'Monomyth' magazine (Atlantean Publishing) in 1986, and again in 2020. His poetry is widely published in the United Kingdom, Australia, The USA and India. His work has appeared in The National Poetry Anthology and 'Heart Shoots' (IDP) in aid of the Macmillan Cancer Charity. David's 83 page poetry collection 'From Time-Buried Years' (Indigo Dreams Publishing) is available from him for £10 (inc p&p) by emailing davidnorriskay@ymail.com PayPal accepted.

He is a member of the ALCS and The Society of Authors.

David is also an accomplished photographer, and has been taking photos of many subjects since he was fourteen years old. The images in this book are fine examples of his photographs of the Peak District National Park, most of them taken in the late 20th century and early 21st century using digital equipment and a few of them were taken by him in the 1960s, 70s and 80s with 35mm film cameras. He continues his interests of writing and photography and will do so until his increasing mobility problems make it impossible to do so.

Please enjoy these photographs which are his way of saving the beauty of his local countryside for posterity.

Publisher

inherit_theearth@btbtinternet.com

Notes

Printed in Great Britain
by Amazon